Published by the Obsessed Photographers Group
314 Central Avenue North
Valley City, ND 58072

ISBN # 978-0-9796821-1-7

Printed by:
Kings Time Printing Press, Ltd.
4245 Hawthorn Place
Ann Arbor, MI 48103

Printed in China

Table of contents

Foreword

by Sheila Anderson

What ties us to this land…

North Dakota is many things to many people. Those of us who are lucky enough to live here are blessed with the richness of the state's varied landscapes, the friendly people, and the character-building, fickle weather that we don't always adore.

Describing North Dakota's beauty to those from other states can be a challenge when the wind is biting your cheeks, taking your breath away, and the high temperature is only -25 degrees. But flip through the pages of *Obsessed with North Dakota* and you will find photos attesting to the wonderful heritage of North Dakota, the strength of its people, and the beauty of the land around us.

Photographers Clint Saunders and Daron Krueger made several trips across North Dakota to photograph the state in each of the four seasons. Considering what they went through to capture images of this state might cause some to question their sanity. But remember, they are obsessed. On the coldest morning of the year, they were not cozy in their living rooms. Instead, they were stuck in a snow bank on their way to photograph a lake in the best light possible.

The resulting book will take you on a tour of North Dakota. The photos in this collection capture the essence of this state, from the humble beginnings of its first settlers, to its diverse landscapes, flora and fauna, and to the ruggedness inherent in the people and their land. Maybe most importantly, the photos offer a glimpse of why we call North Dakota home.

The Plains

According to Daron

I have always appreciated the vast spaces of North Dakota. The seemingly endless skies provide beautiful cloud formations and breathtaking sunsets, while the growing seasons of the various crops constantly change the colors of the landscape. From a lonely tree standing in a field to railroad tracks disappearing in the distant horizon, the vastness provides beauty everywhere.

It is a challenge to create photographs that capture the prairie in a way that allows the viewer to share that sense of relaxed freedom. Without mountains rising in the distance or constantly rolling hills and valleys, the depth needed to convey that openness has to be achieved using other elements. Things such as cloud formations, shadows on the ground, atmospheric conditions and even the format of the image itself play a vital role in the composition.

The unpredictable weather of the plains adds a level of satisfaction to every successful shooting excursion. Weather systems move rapidly over the prairie, continually changing the light and the entire essence of a scene. Other phenomenon, such as the mystical ground fog and hoar frost created by subzero temperatures, can vanish in minutes. Successfully exploiting these conditions to enhance an image is especially rewarding.

The plains have a beauty all their own, and finding creative ways to convey the contentment this open space provides is a fascinating endeavor.

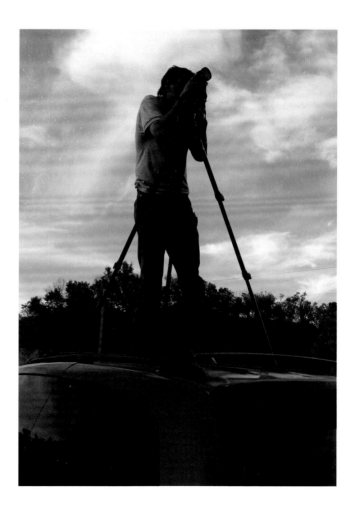

The Plains

According to Clint

When I think of North Dakota, I think of the plains. Lone trees, vast fields, gentle rolling hills, and skies that go on forever. And, just when I think I'm in the middle of nowhere, I find signs of civilization.

Agriculture, country churches, railroads, wind farms, and old country roads remind me that I'm not alone out here. For, no matter how rugged or vast the plains seem to be, there are people living out here. There are people working the land and making a living despite the rugged terrain and (often) hostile weather.

Our winter photo shooting tour of the state proved to be my most memorable. One morning, temperatures dropped to a near record breaking 44 degrees below zero. The air stood still and time seemed to stop as we set up our tripods and waited for the sun to rise. The plains had a surreal quality that morning that brought to mind a frozen, uninhabited landscape of a distant planet. Seven of the images in this section came from that morning.

In addition to the breathtaking beauty, I'll never forget that day because I managed to bury the van in a snow bank while approaching Nelson Lake. (Nearby BNI coal prevents Nelson Lake from freezing. We were thus determined to get a shot of the resulting fog rising off the lake.) After 3 ½ hours of digging a BNI worker contacted his co-workers who arrived on the scene with a tow rope. We'd probably still be there had it not been for their help. THANKS GUYS!

Our beards were pierced with icicles and our bodies were frozen and sore—but our main concern was that we had lost the best light of the day. Fortunately, I captured a photo of some frosted trees in the fog on our way out, so the trip to Nelson Lake was not wasted.

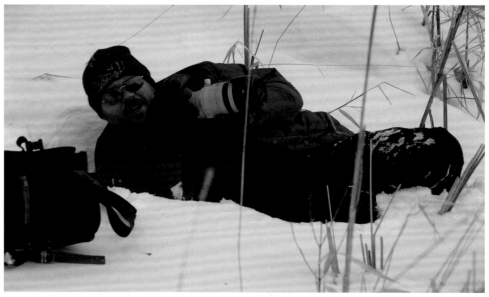

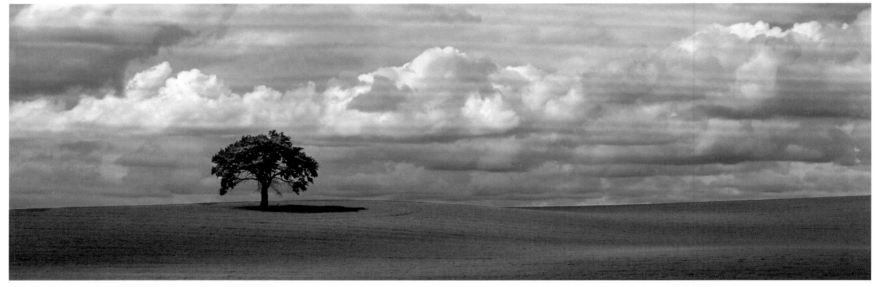

I-94 Tree #2 Daron W. Krueger

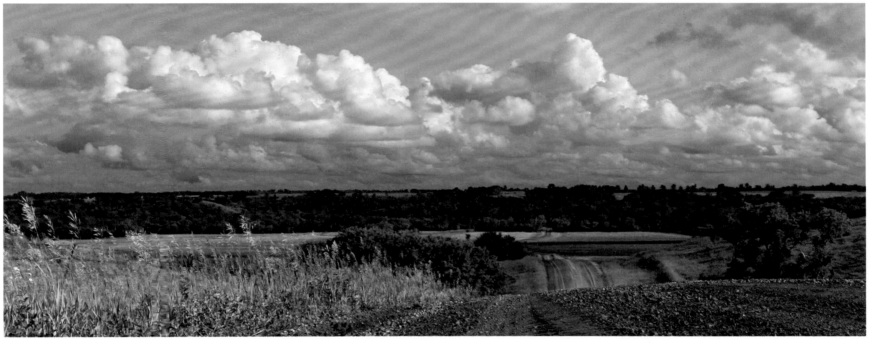

Panoramic Valley Clint Saunders

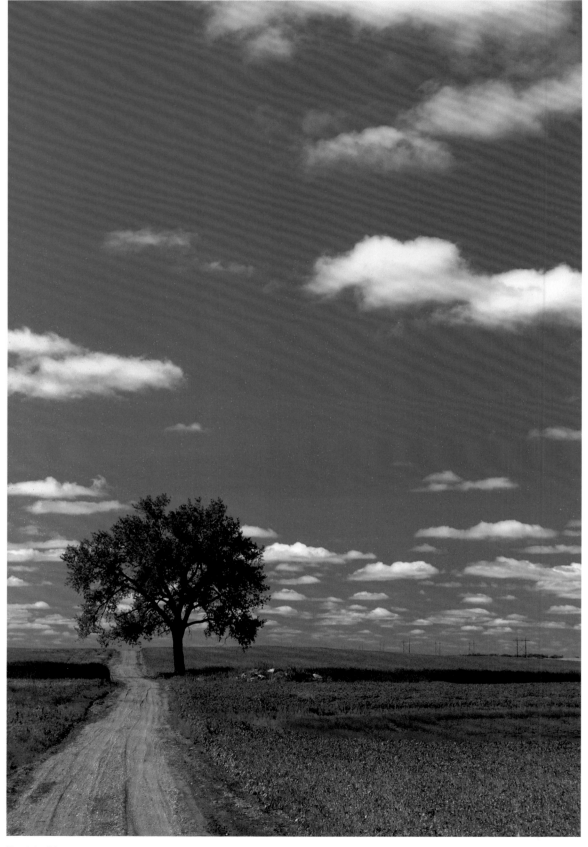

Prairie Tree Daron W. Krueger

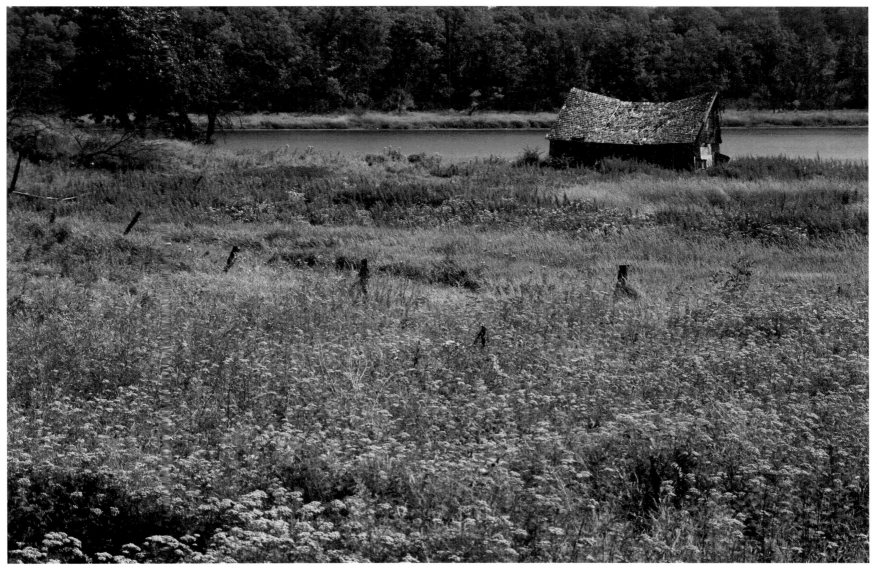

Turtle Mountain Shack

Clint Saunders

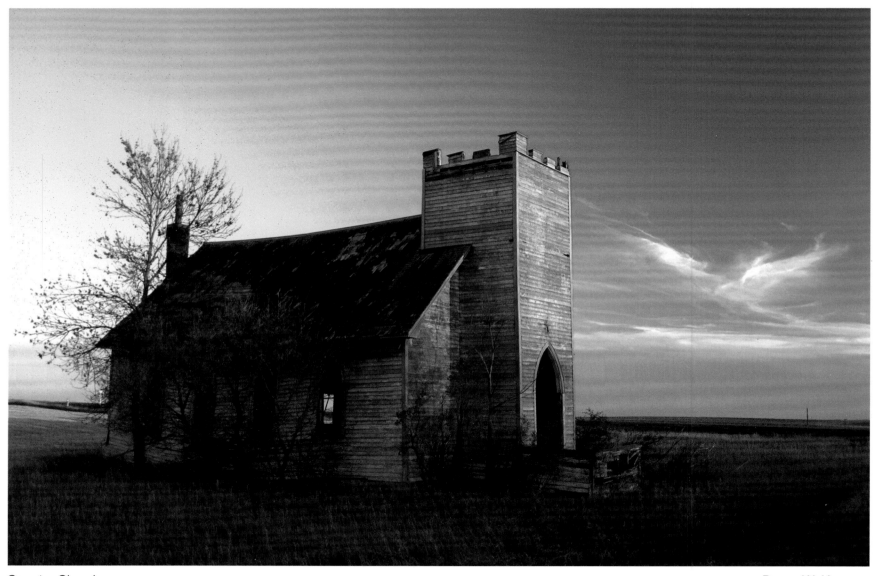

Country Church

Daron W. Krueger

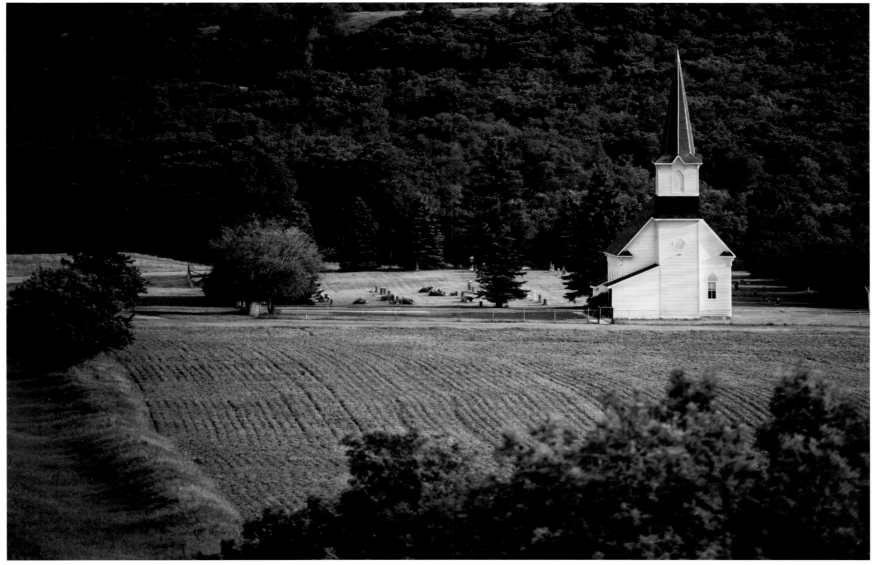

Valley Church

Clint Saunders

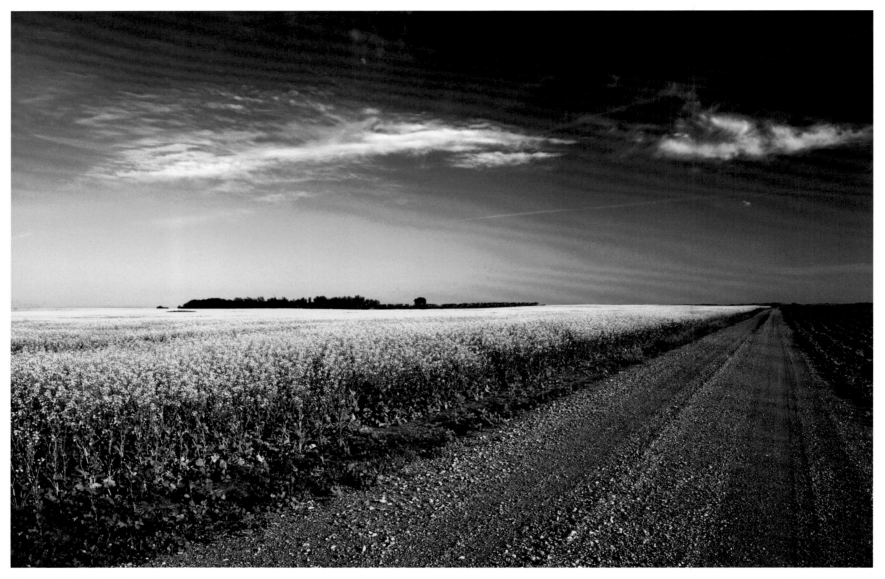

Mustard On the Side Clint Saunders

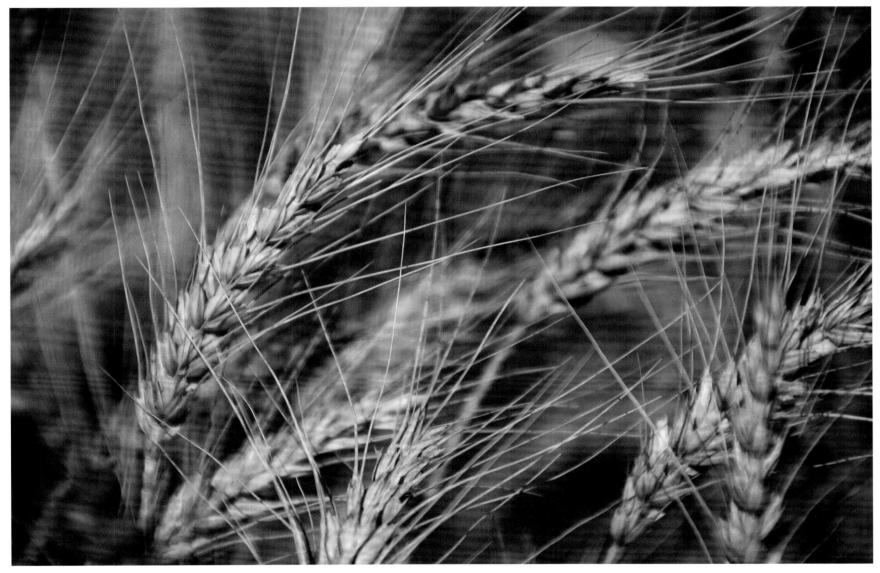

Wheat

Clint Saunders

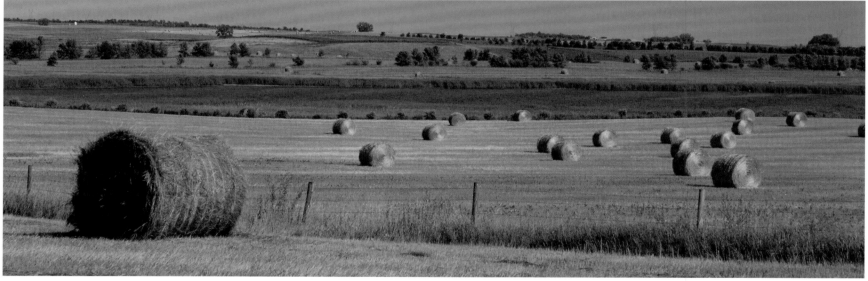

Panoramic Bales #3

Daron W. Krueger

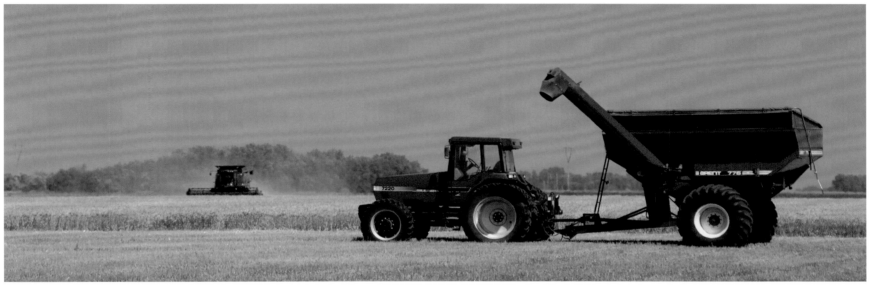

Harvest

Daron W. Krueger

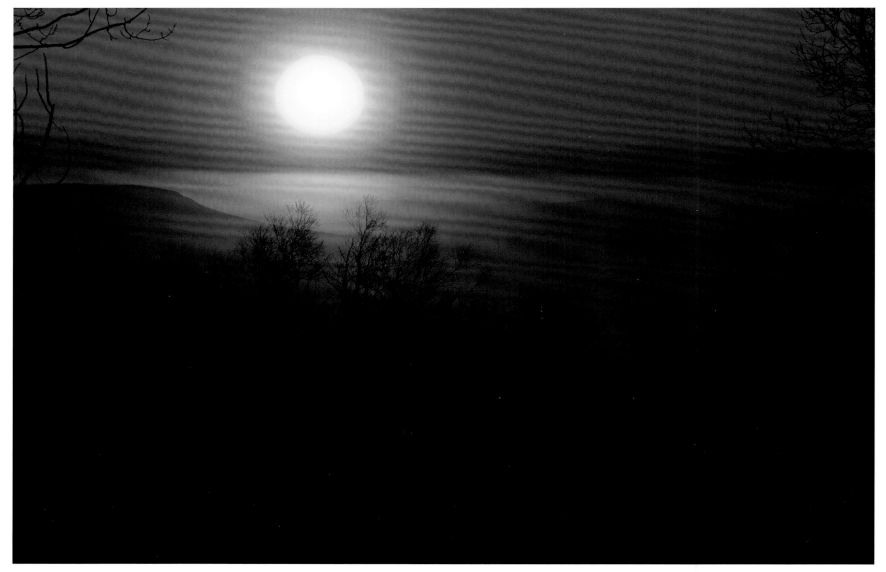

Frigid Grandeur Daron W. Krueger

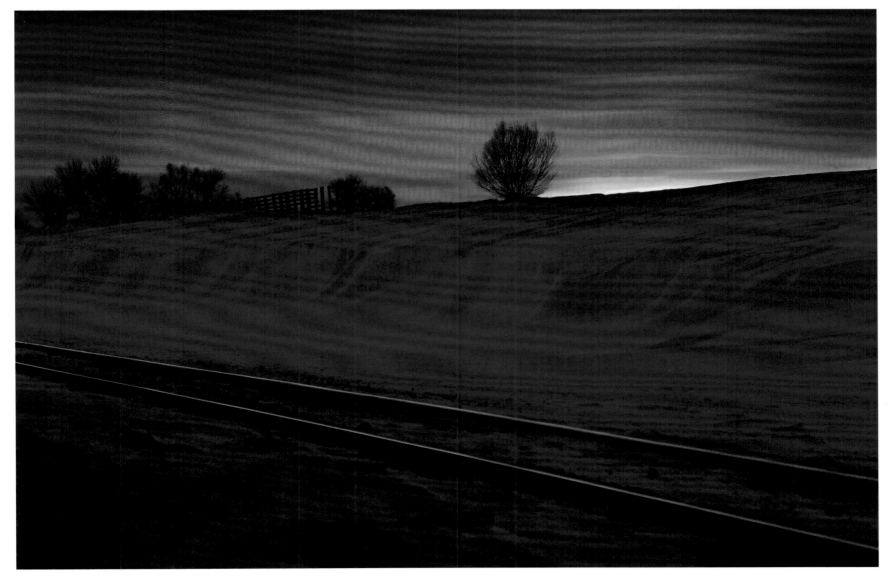

Old Depot Sunset

Clint Saunders

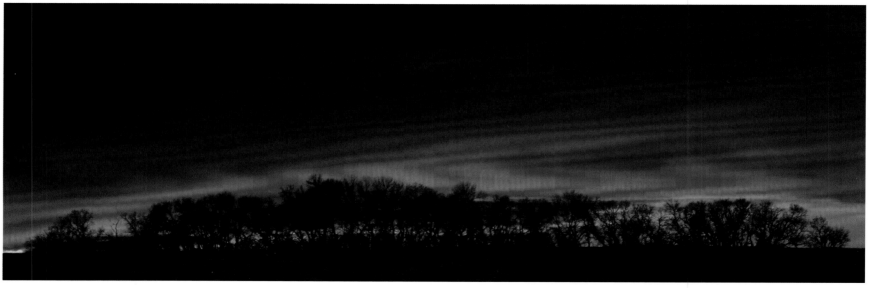

Winter Treeline Clint Saunders

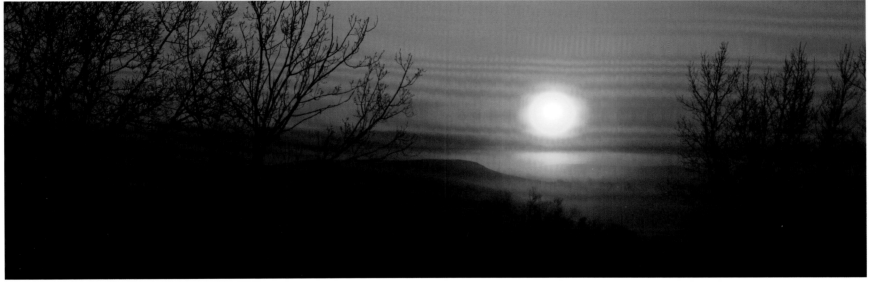

Sunrise at 44 Below Zero Clint Saunders

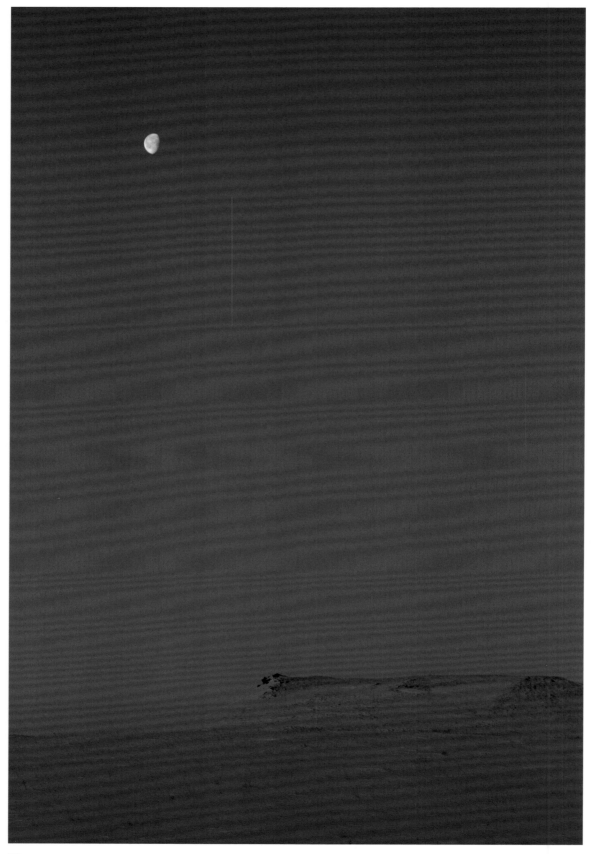

Blue Daron W. Krueger

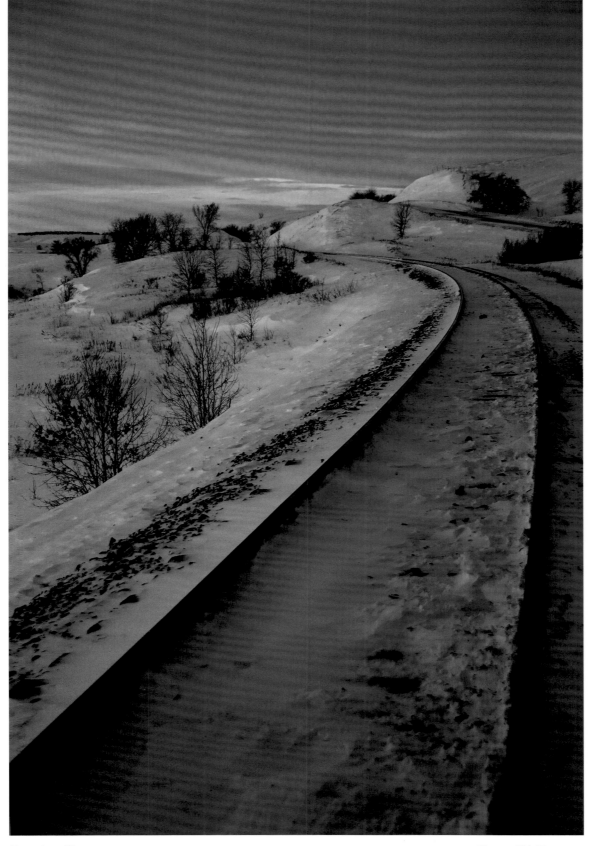

Evening Glow

Daron W. Krueger

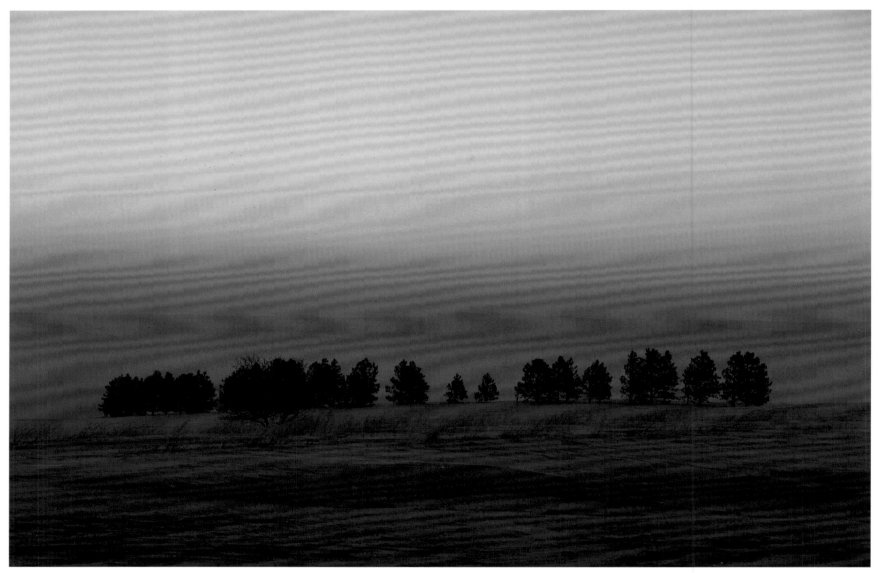

Tundra Fog

Daron W. Krueger

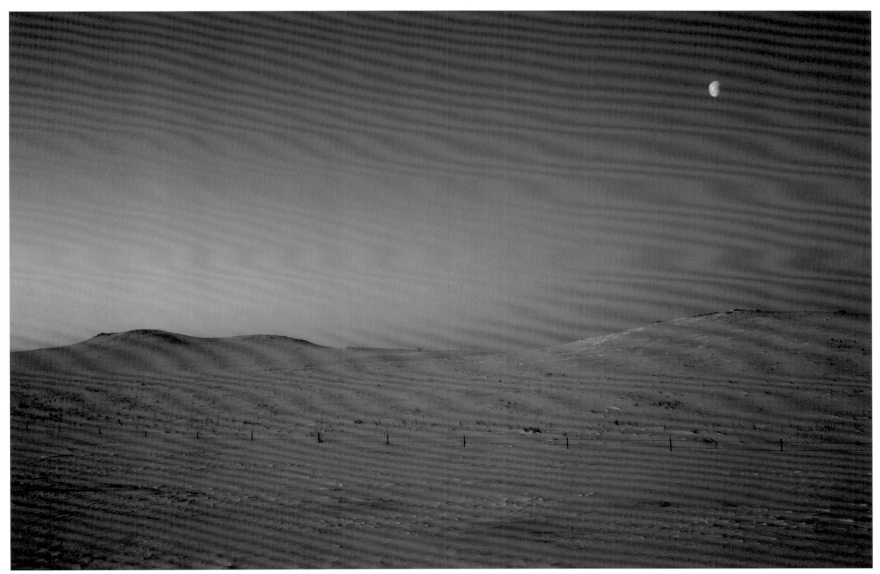

Frozen Moon Clint Saunders

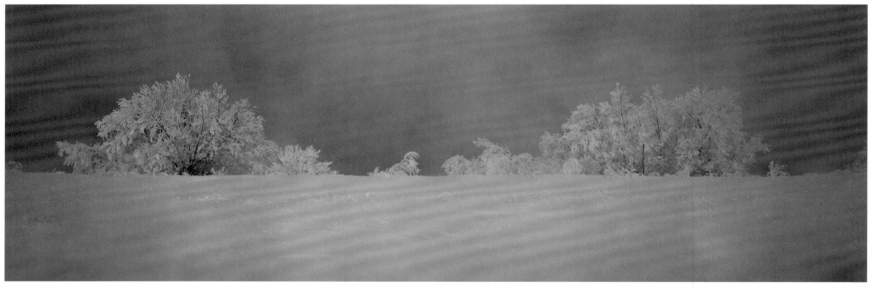

Blue Fog

Clint Saunders

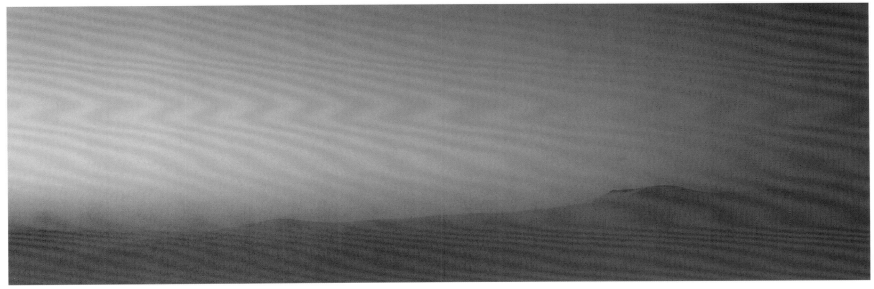

Serenity at 44 Below Zero

Clint Saunders

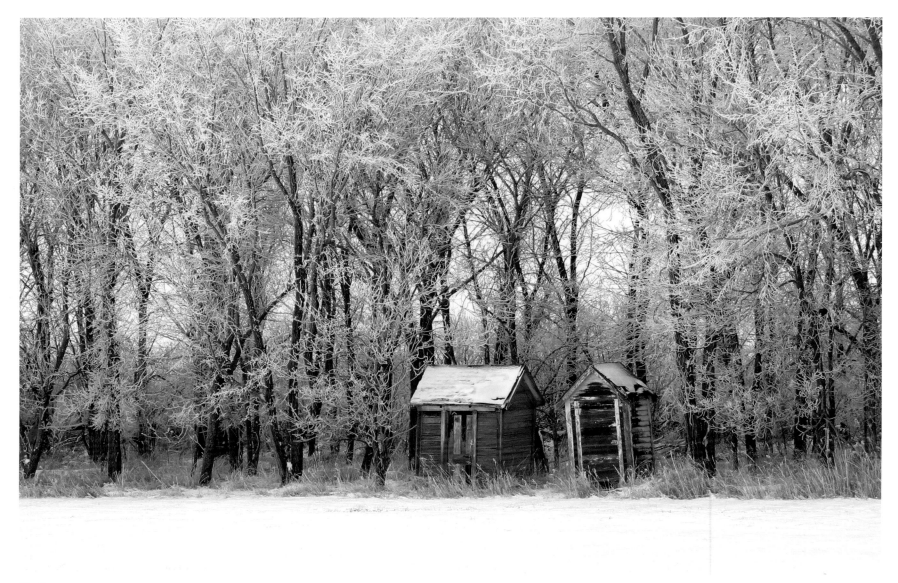

Outhouse

Clint Saunders

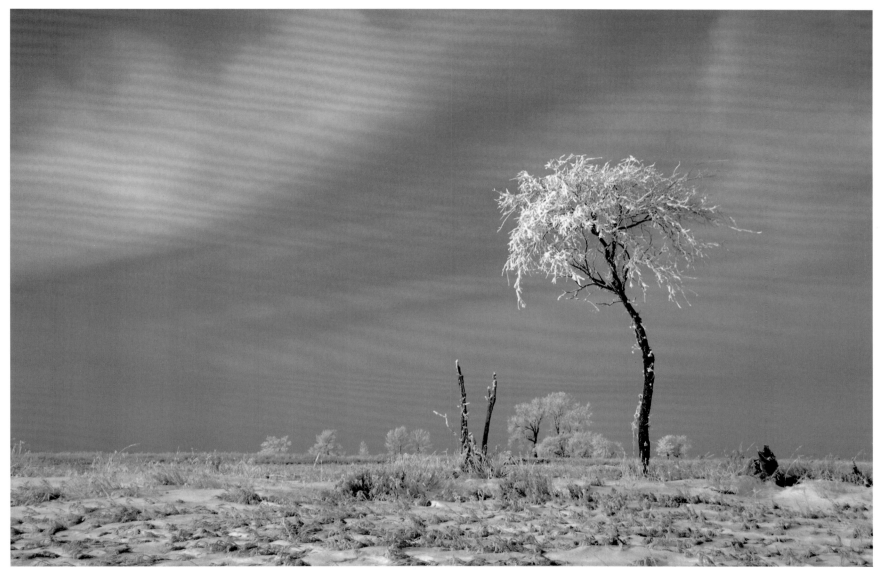

Frosty Tree

Daron W. Krueger

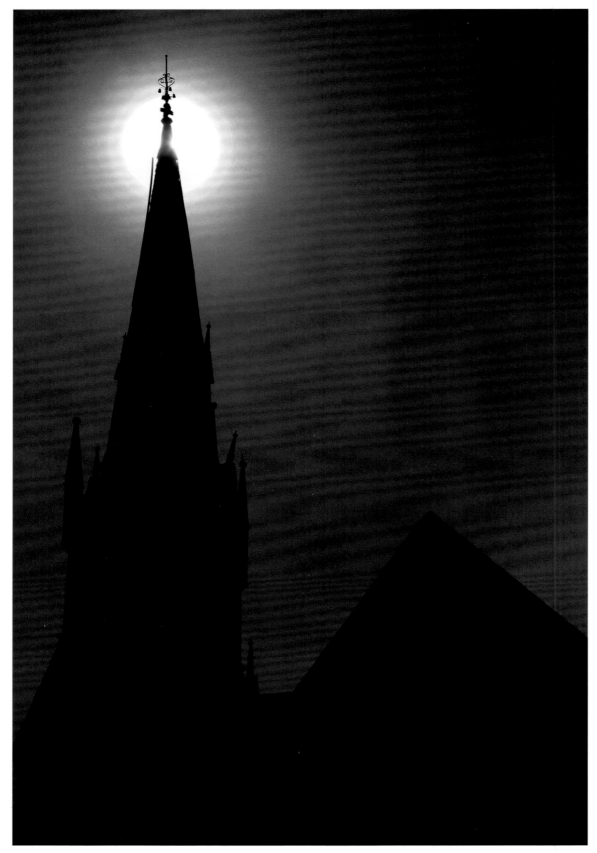

Spire

Clint Saunders

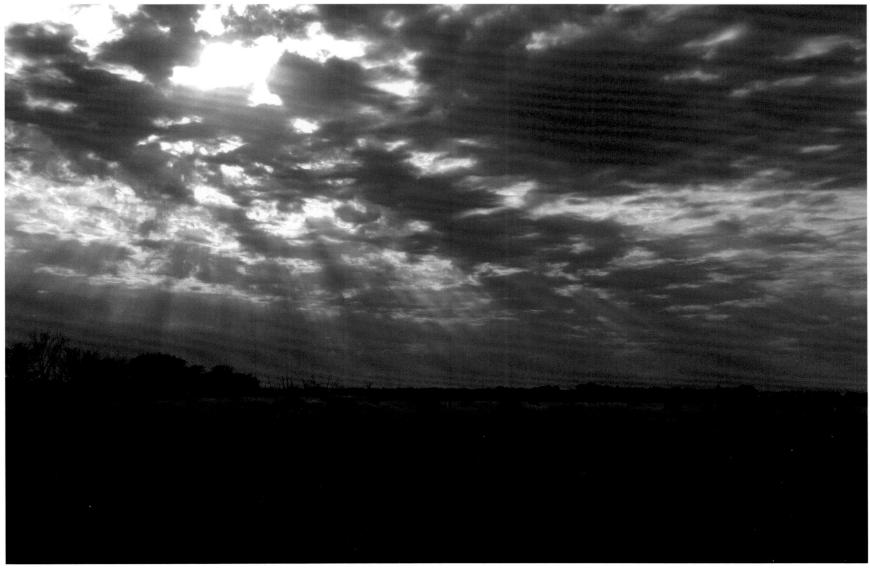

Sunbeam Bales

Daron W. Krueger

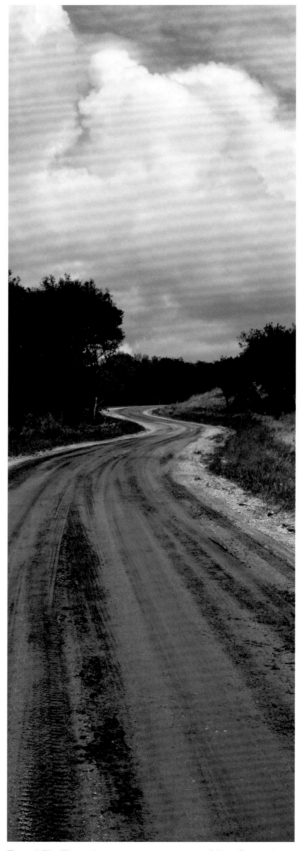

Road To Fingal Clint Saunders

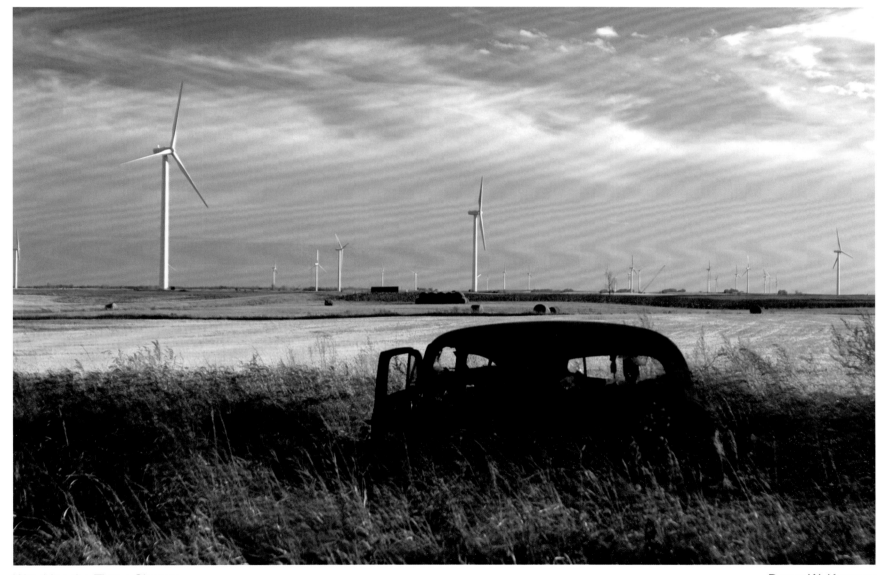

Watching the Times Change Daron W. Krueger

Rustic

According to Clint

One of the great things about North Dakota is that we are not overpopulated and have an abundance of space. It's this roominess that allows us to build new without tearing down the old. This makes me happy because I love photographing rustic stuff. The colors, textures, and character of these rustic objects makes for wonderful photographic images that also have a sense of nostalgia.

To outsiders, such as the people from National Geographic magazine, these rustic images are a sign that North Dakota is a wasteland that is dying and rapidly becoming one large ghost town. However, to the fine people who live in North Dakota we know that these are signs of prosperity as well as being a tribute to the craftsmanship of our ancestors and a preservation of our history.

That rusted out abandoned tractor sitting in the ditch doesn't mean the farm died, it means that someone got a new tractor. The old, paint stripped house is a sign that someone built a new house somewhere else on the land. When the pick-ups have about a million miles on them, they are parked and replaced with new ones.

The decaying objects in our rustic images aren't a sign of a dying state, they are a tribute to our culture, our history, our way of life and they also just happen to make wonderful subjects for photographs.

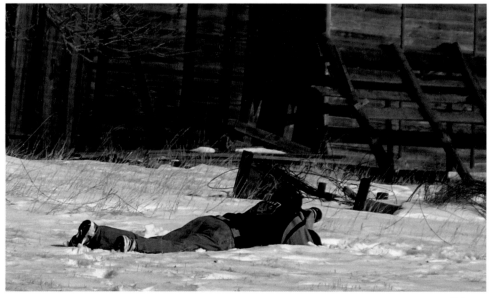

Rustic

According to Daron

Photography started for me in rustic scenes. I had always yearned to explore and photograph abandoned farmyards. When I finally acquired a camera and started exploring, the experience was much more than the pleasant pastime I had envisioned--the entire process of photography took me to a whole new realm. Deciding how to portray my discoveries and convey the mood of the scenes was mesmerizing. I've been obsessed with every aspect of photography, from discovery to print, ever since.

Abandoned farmyards continue to be one of my favorite subjects. I never tire of exploring them, looking for treasures from the past to examine and highlight. Using color, texture and perspective, I try to create interesting views of prairie life, while giving recognition to the beauty and function of common objects normally taken for granted.

The surviving remnants give testament to the craftsmanship and hard work of those who settled the land. The images created in these places are quite moody, but they pay tribute to a time of close families and communities.

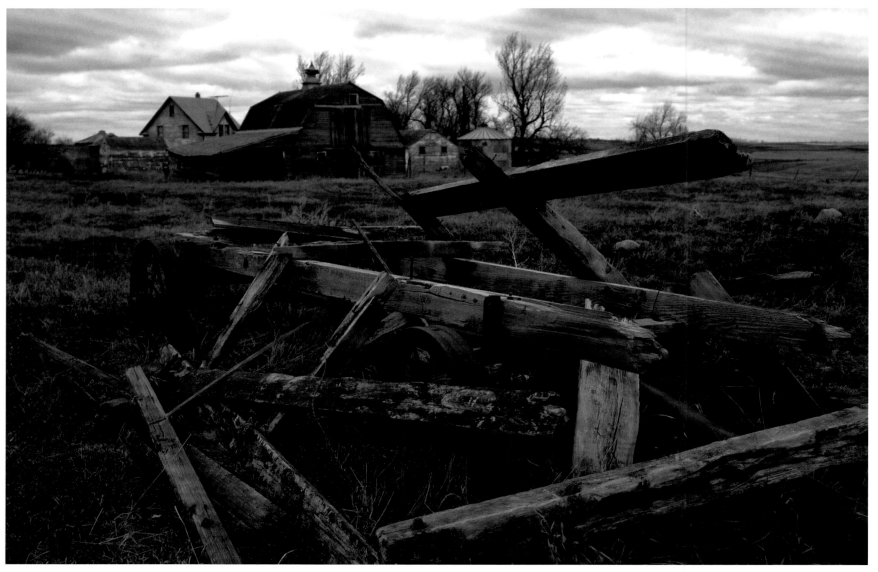

End of an Era

Daron W. Krueger

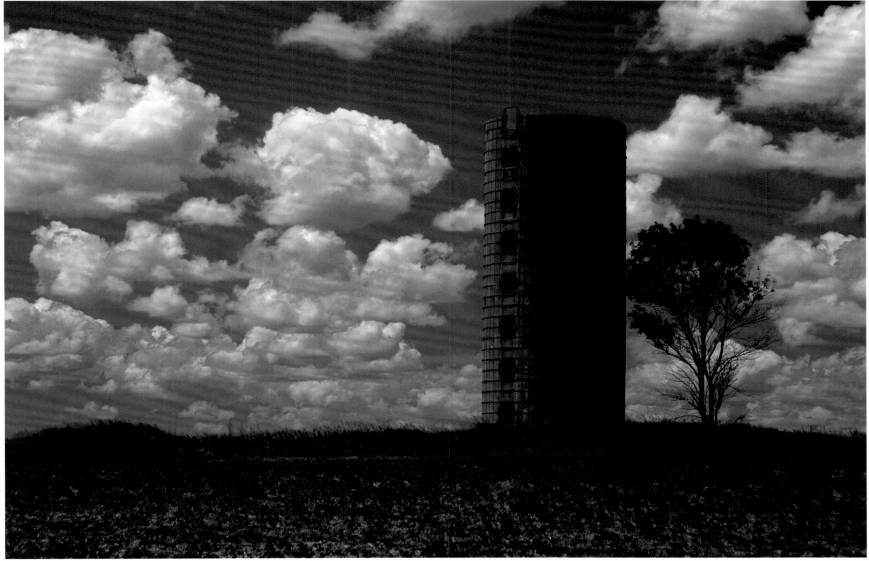

All That Remains Daron W. Krueger

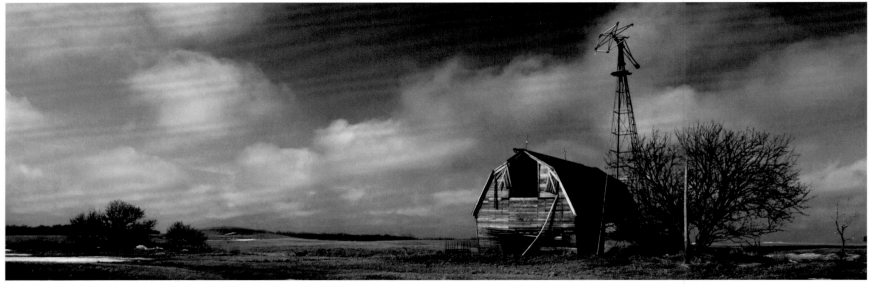

Bleak Daron W. Krueger

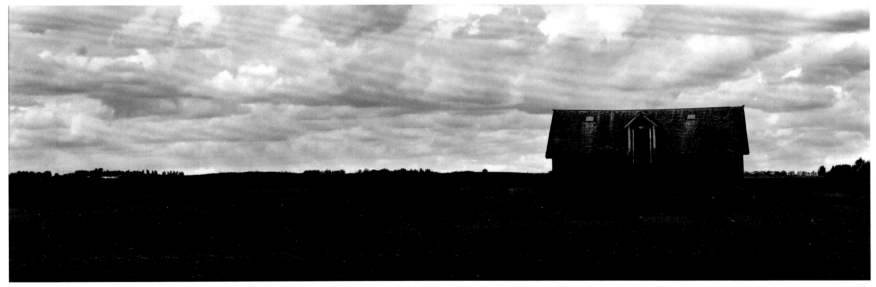

Abandoned Barn

Clint Saunders

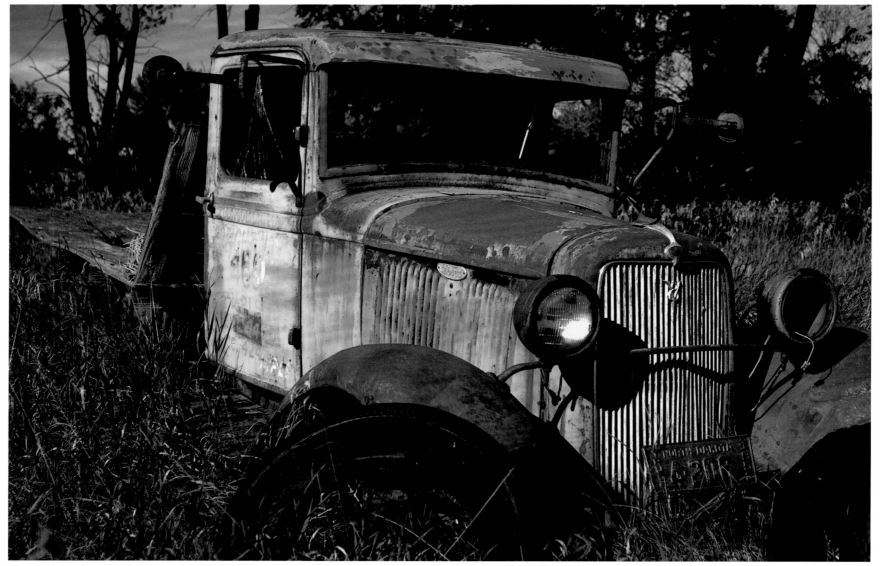

Exhausted

Daron W. Krueger

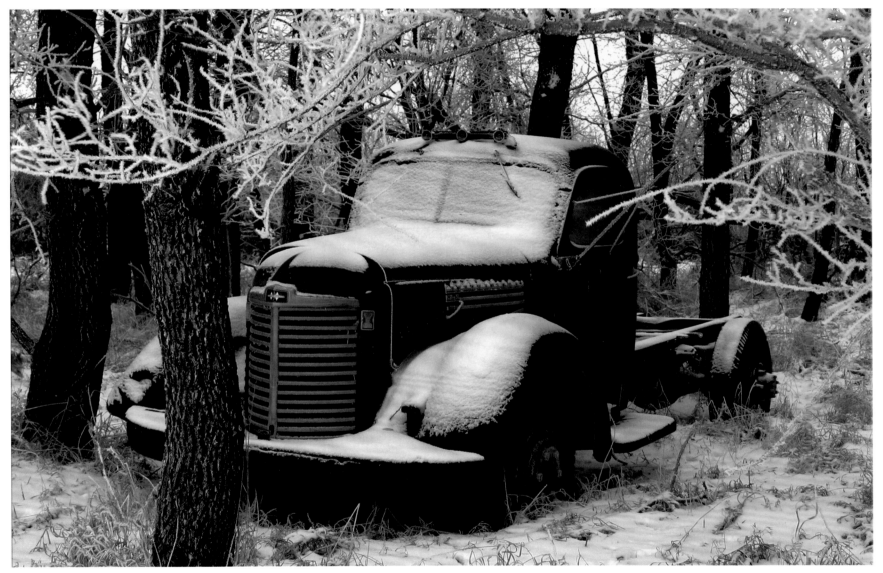

Forgotten Clint Saunders

Ladle

Clint Saunders

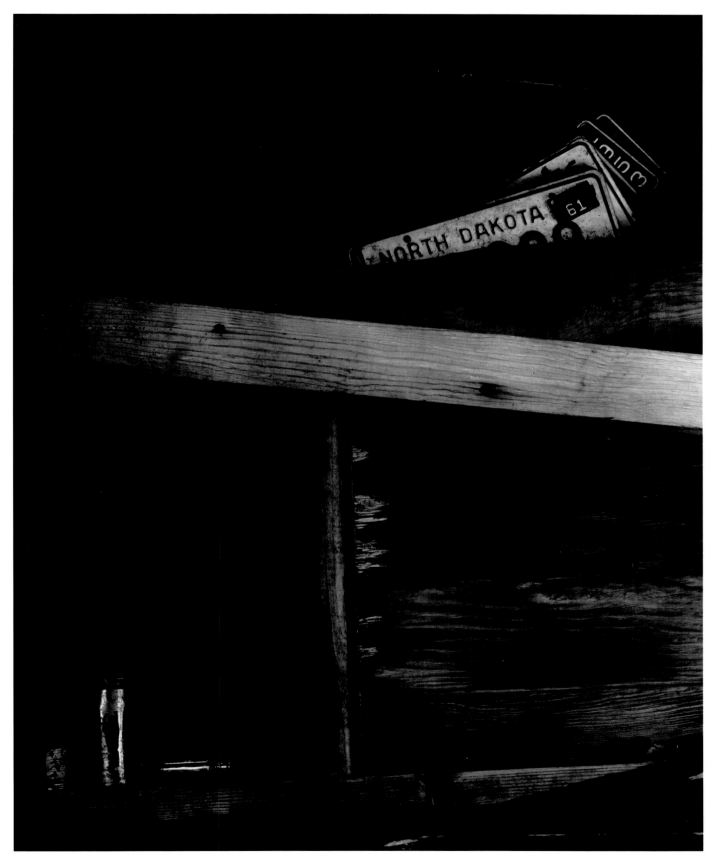

License Plates

Clint Saunders

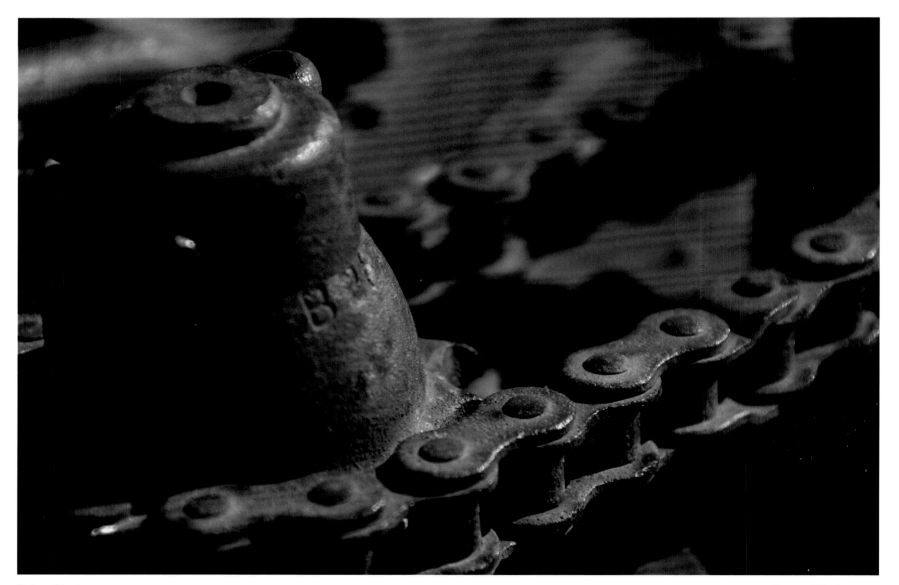

Drive Chain

Daron W. Krueger

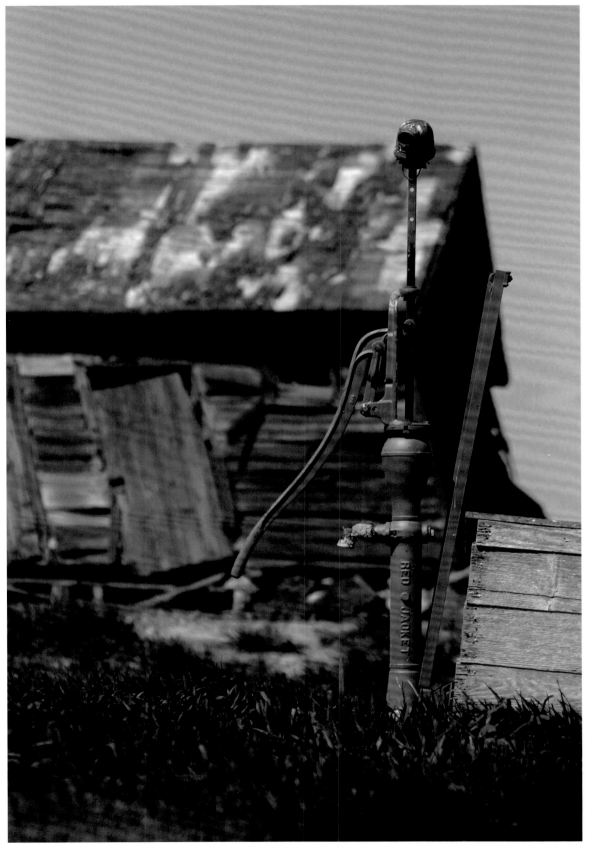

Red Jacket Sepia

Daron W. Krueger

Wheel Detail Daron W. Krueger

At the Ready

Clint Saunders

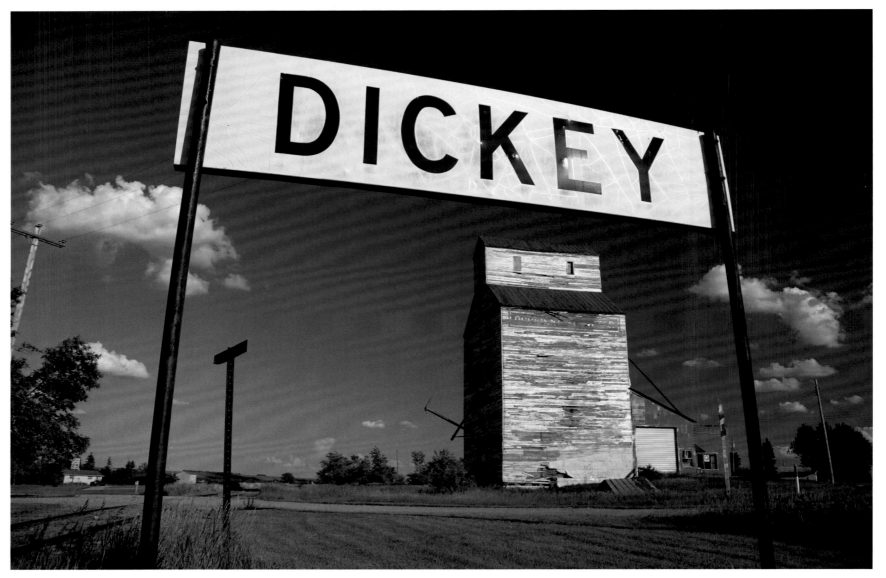

Dickey

Daron W. Krueger

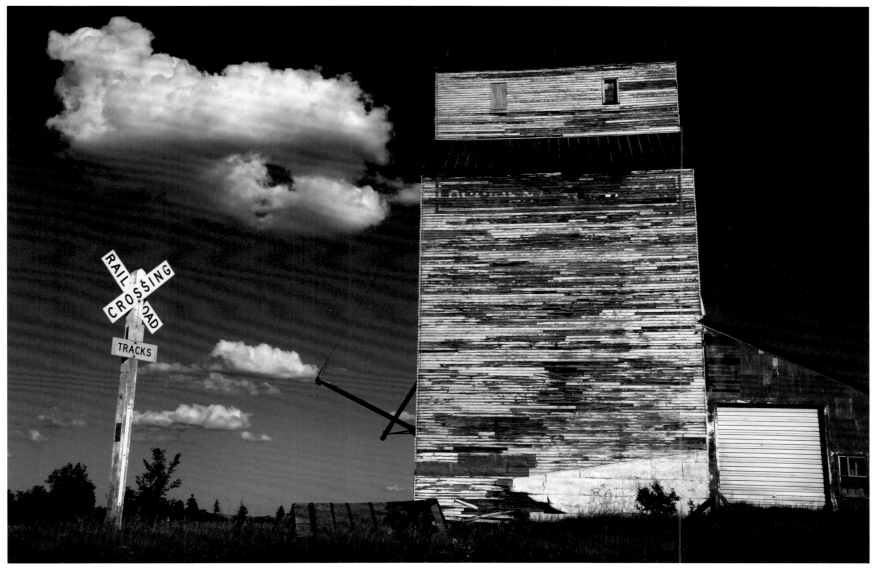

Dickey Elevator

Clint Saunders

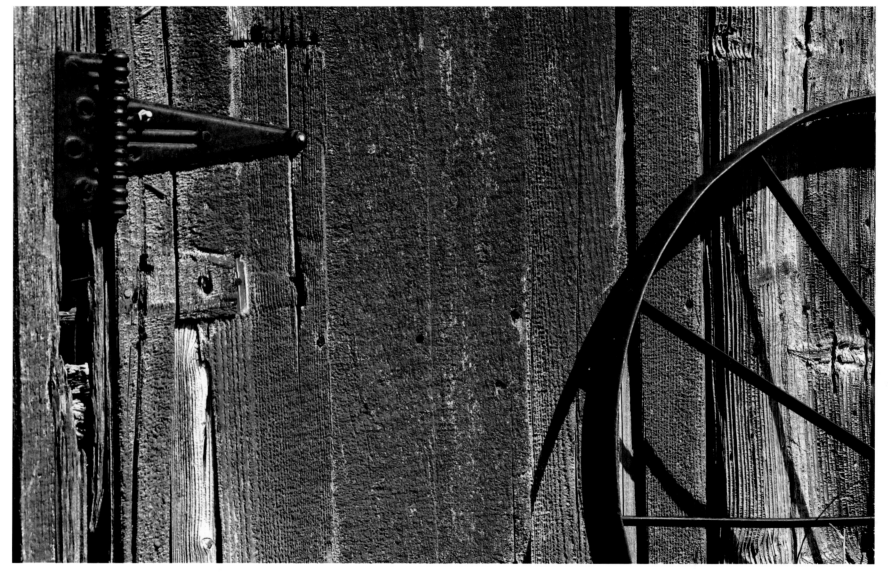

Door Stop

Clint Saunders

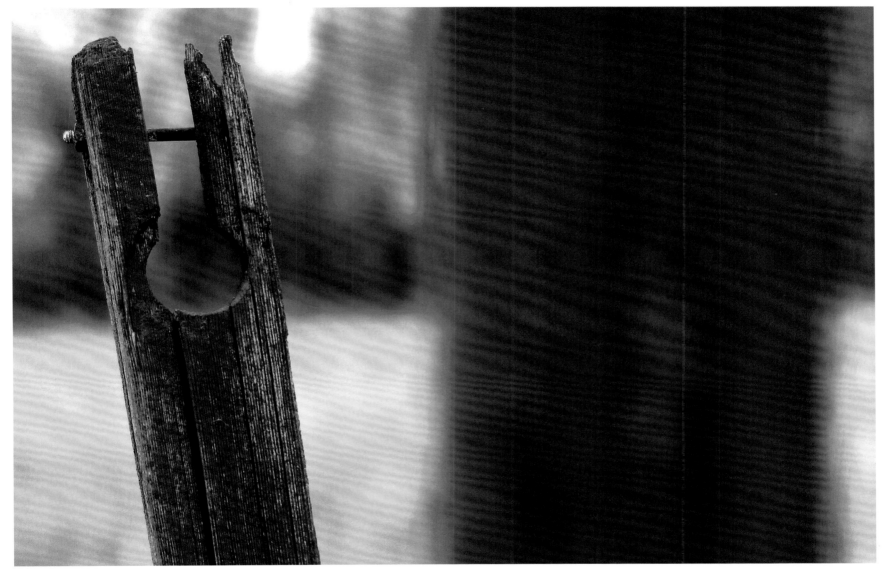

Keyhole Post

Clint Saunders

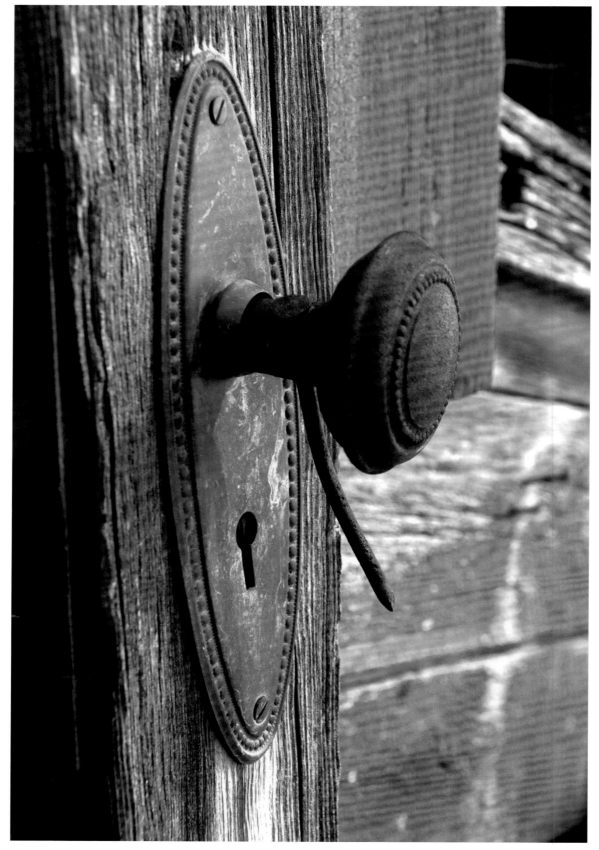

Nailed Together

Daron W. Krueger

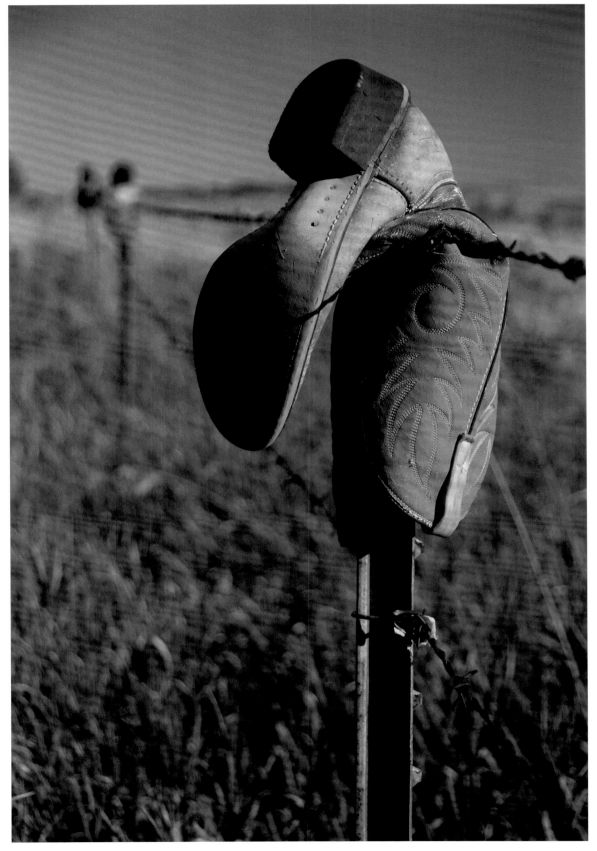

Boot Fence Daron W. Krueger

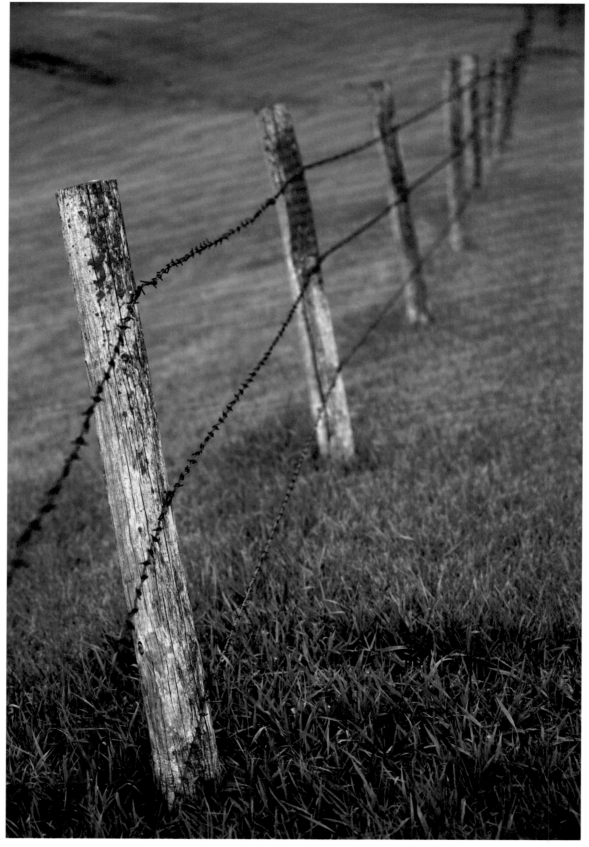

Fence Clint Saunders

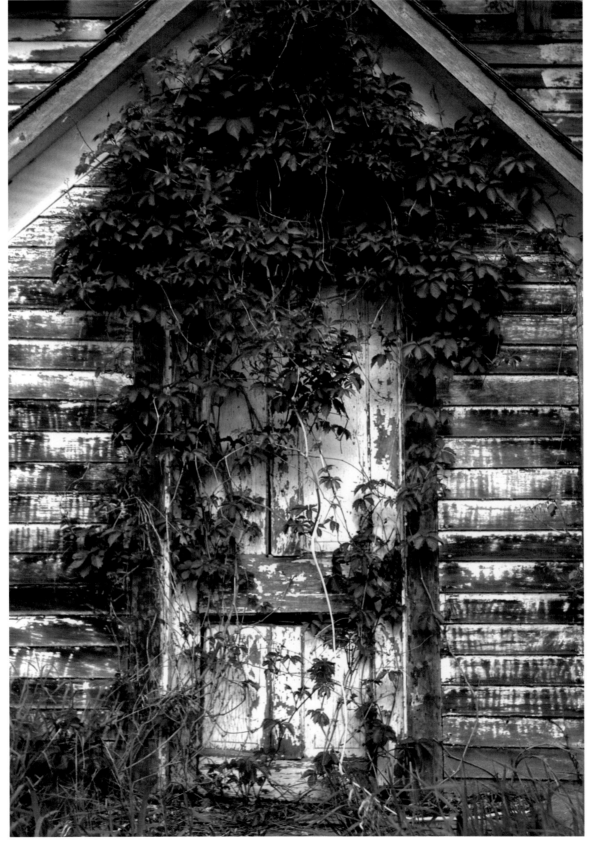

Overgrown Daron W. Krueger

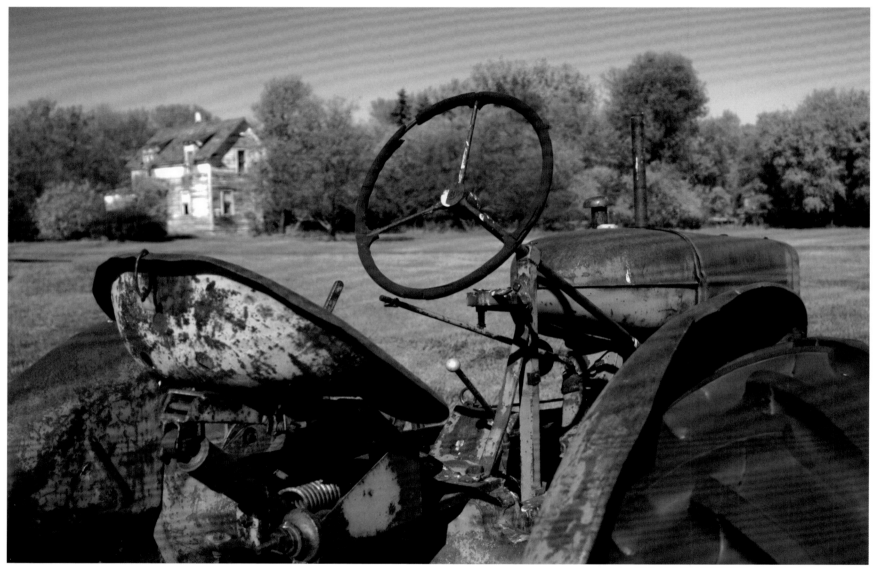

Retired

Daron W. Krueger

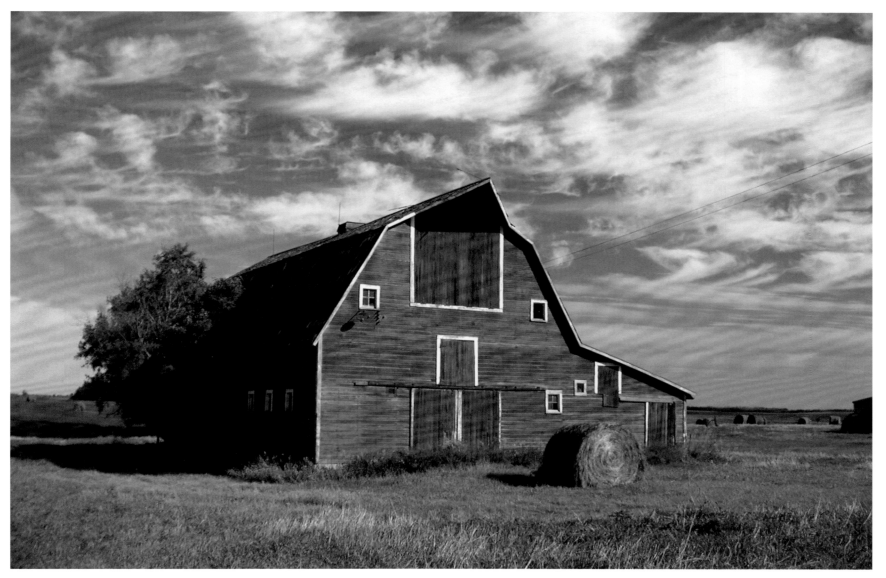

Barn #1

Daron W. Krueger

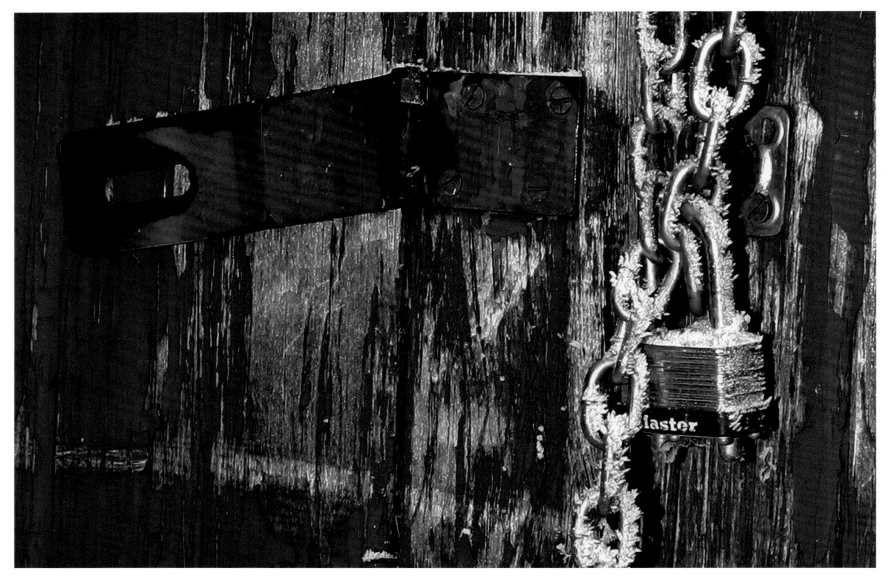

Frosty Lock Clint Saunders

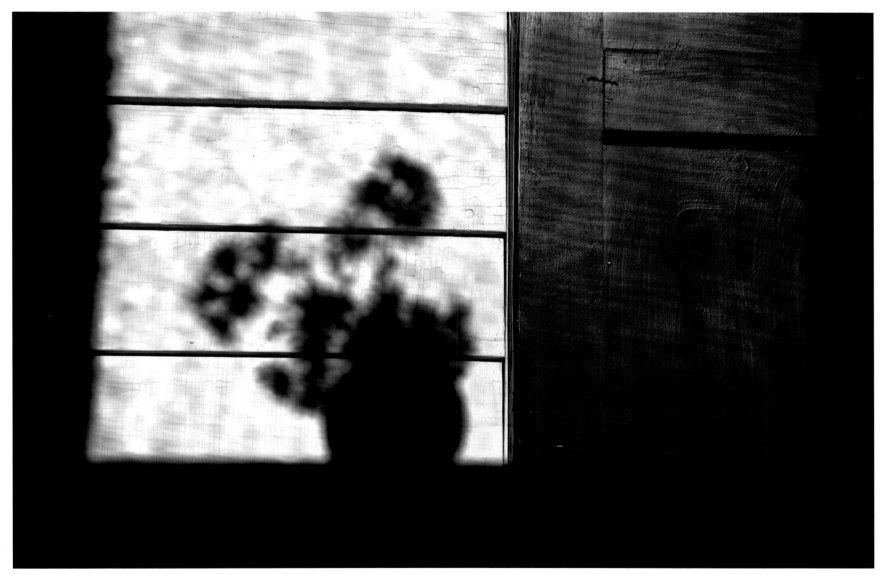

Shadow of the Past Daron W. Krueger

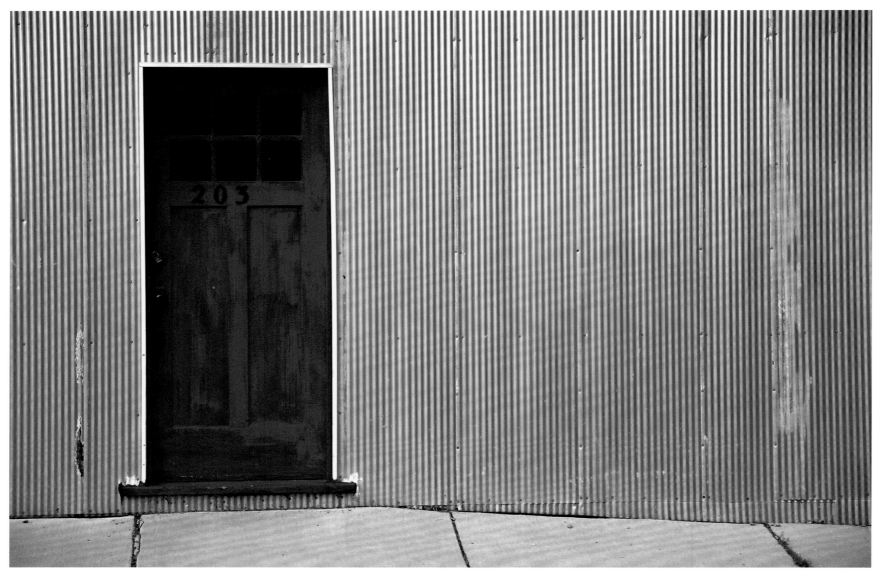

Red Door Clint Saunders

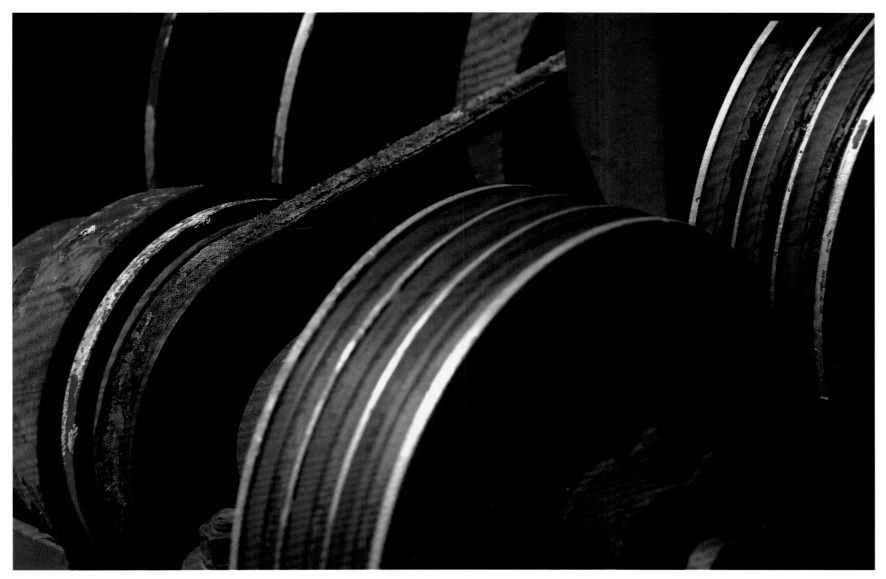

Last Belt Daron W. Krueger

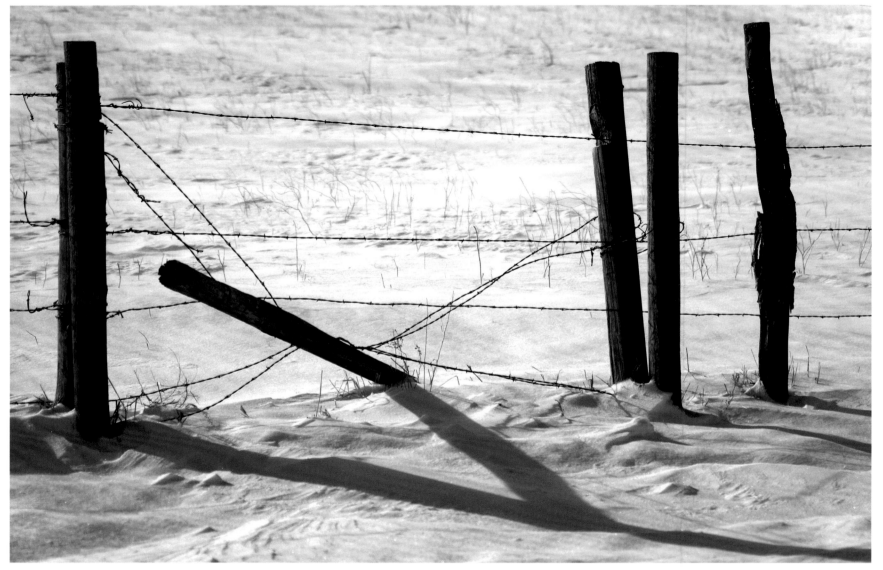

Mended Fence Clint Saunders

Family Room

Clint Saunders

Miscellaneous Landmarks

According to Clint

North Dakota has many recognizable landmarks, from the Veteran's Cemetery, to the Mystical Horizons and Peace Gardens, to some of the unique and even famous bridges. While we don't have images of every North Dakota landmark, we do have a few landmark images that we print and carry in the gallery.

Miscellaneous Landmarks

According to Daron

Ursa Major at VCSU is an example of great timing—a demonstration that being obsessed can produce great opportunities. While I'd love to claim that I studied star charts and planned for months, the scene was a tremendous stroke of luck. I climbed the fire escape on the main campus buildings at Valley City State University--in the middle of the night--to search for a unique perspective on the clock tower. As I pondered various compositions, I discovered the Big Dipper perfectly posed in the sky above the spires. Lying on the roof to get the correct angle, I was able to get an uncommon image of a very common subject. I often say that photography requires tenacity--going out often and at odd times, and to difficult places. My willingness to explore was well rewarded that night.

The Veterans' Memorial Cemetery, south of Mandan, is a place I had meant to photograph many times but hadn't. So when traveling for this book we made a point of stopping there to photograph the sunrise. The sky was clear, the air was crisp, and as the sun cleared the horizon it lit the stones with a warm glow. We were engrossed for quite some time, finding different ways to convey the majestic aura, the significance of the location, and the deep reflection they inspired. We left with several powerful images, but chose just one each for this publication.

Living in the "City of Bridges" gives us daily opportunities to photograph the historic bridges in Valley City. We have included some of our most popular images, along with a few other bridge photos from around the state.

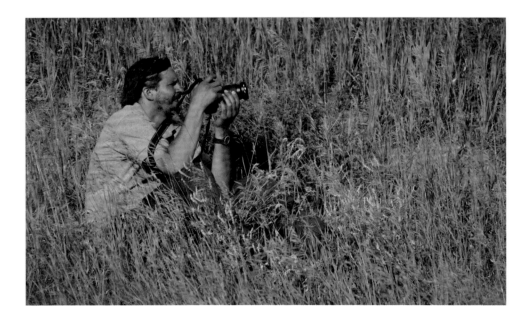

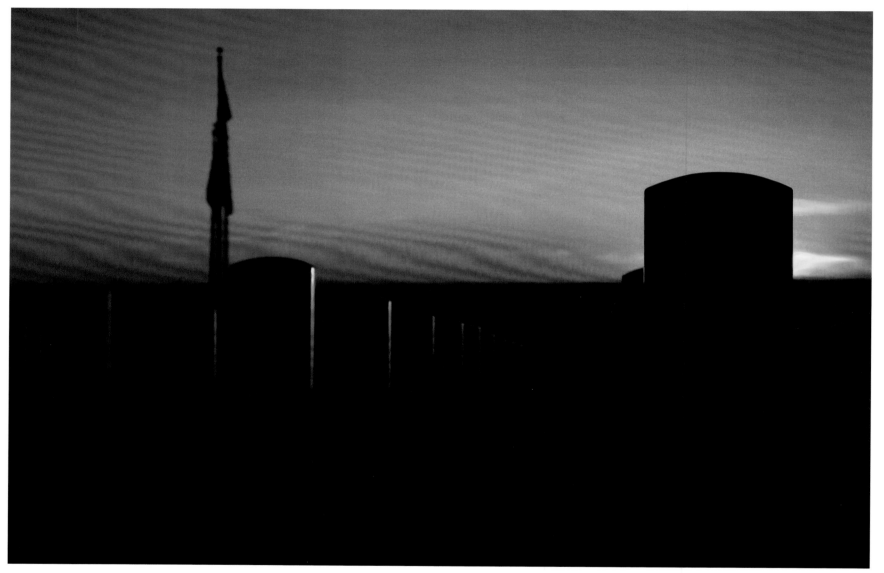

Taps

Clint Saunders

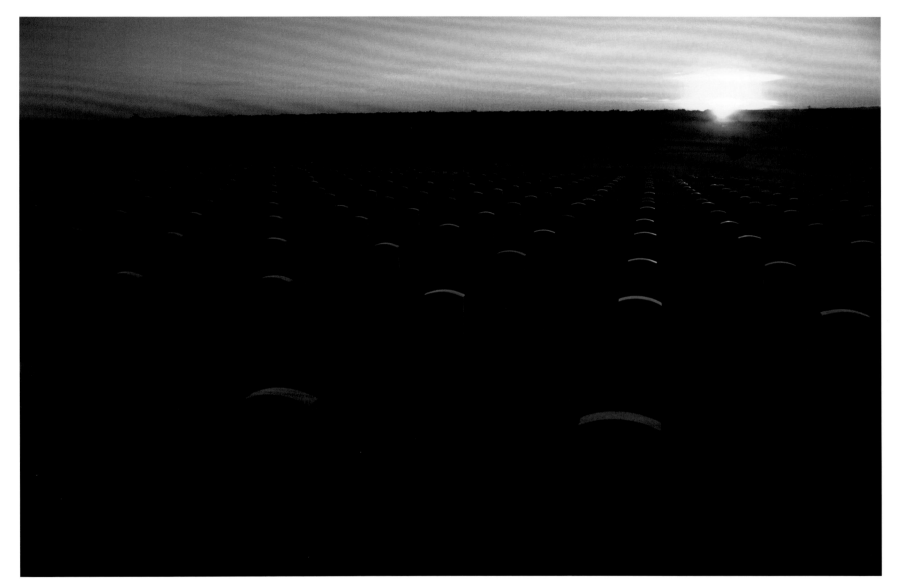

Veterans Cemetery

Daron W. Krueger

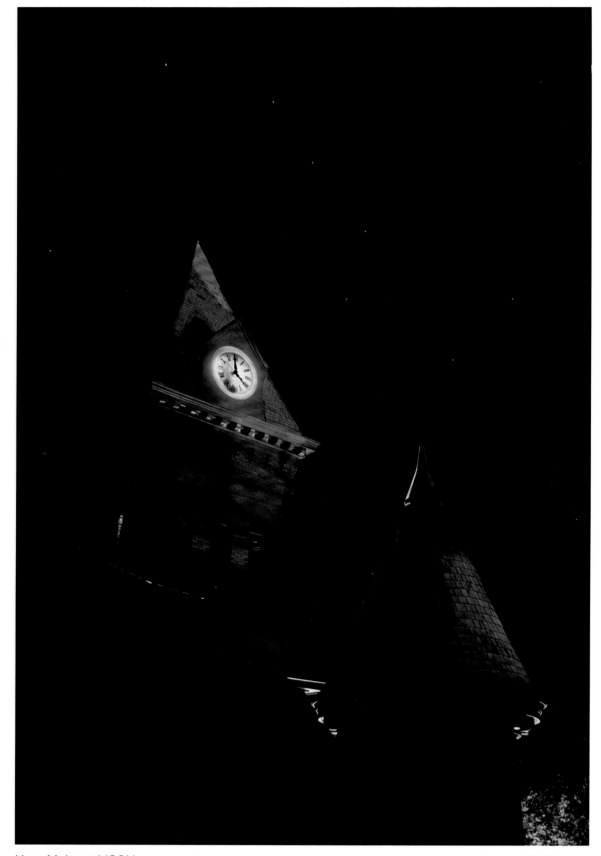

Ursa Major at VCSU Daron W. Krueger

Mystical Horizons Daron W. Krueger

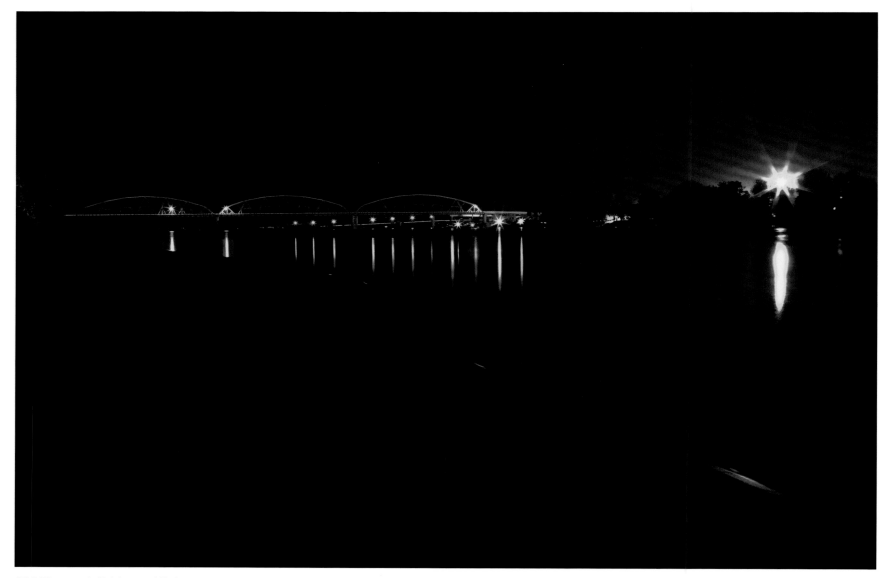

Old Bismarck Bridge at Night

Clint Saunders

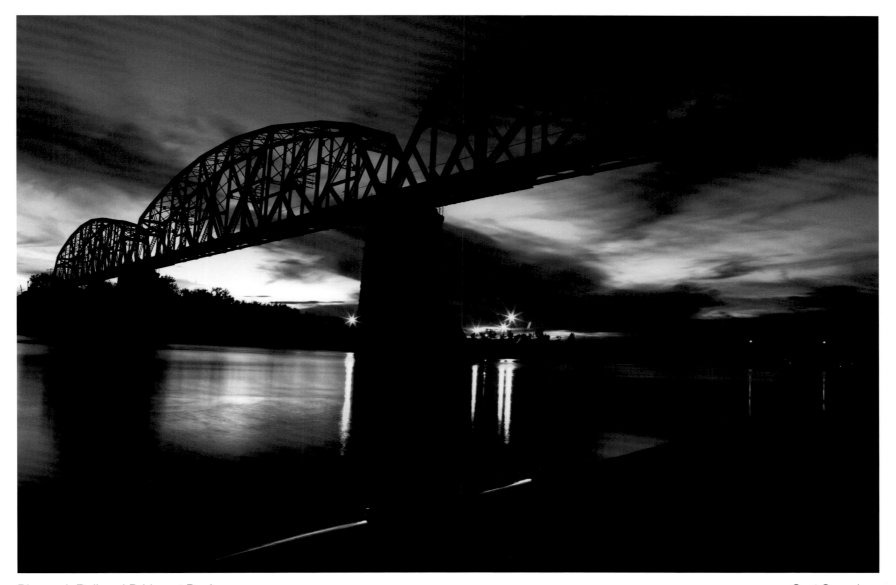

Bismarck Railroad Bridge at Dusk

Clint Saunders

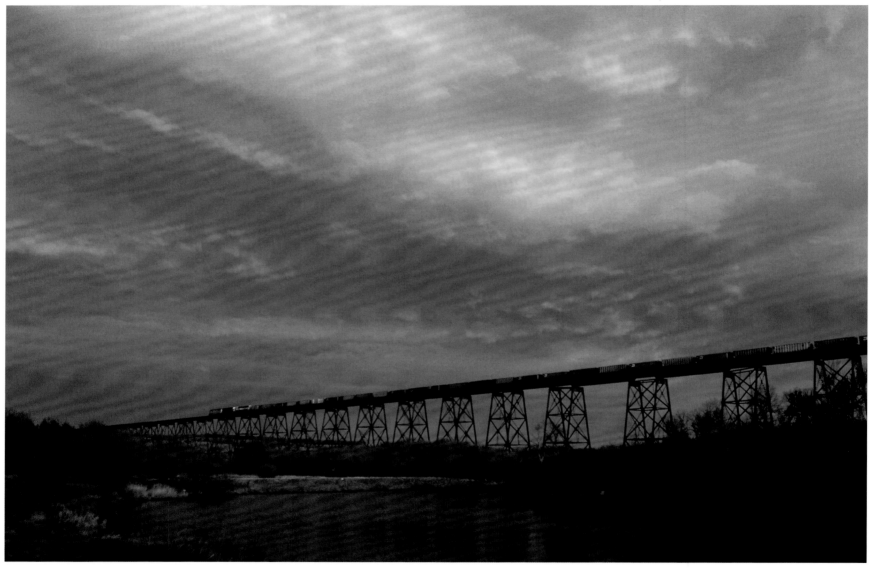

Twilight

Daron W. Krueger

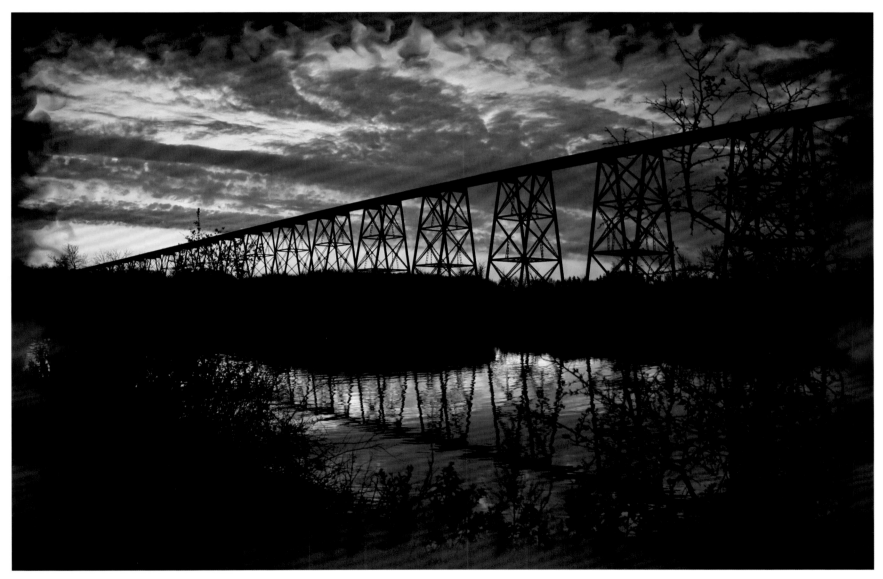

Hi-Line 62

Clint Saunders

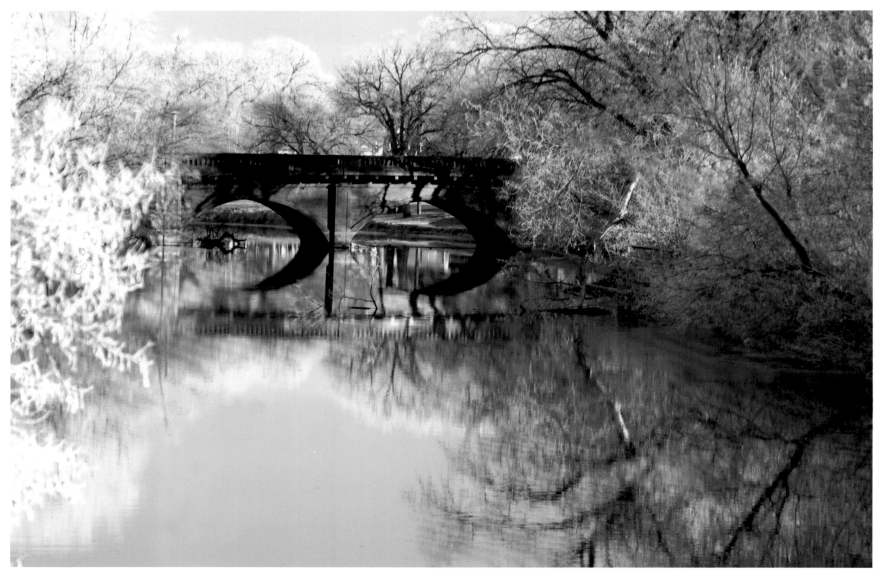

Frosty Morning

Daron W. Krueger

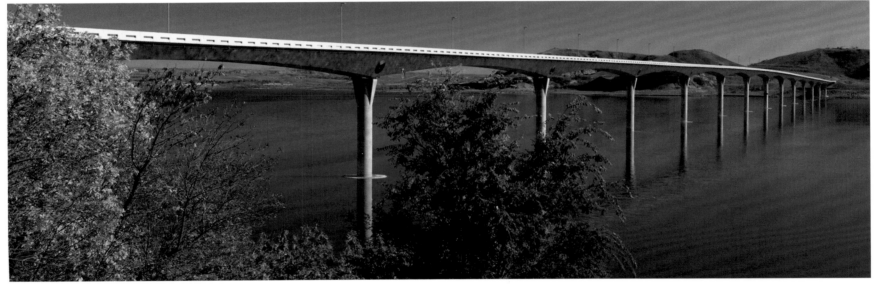

Four Bears Bridge #3

Daron W. Krueger

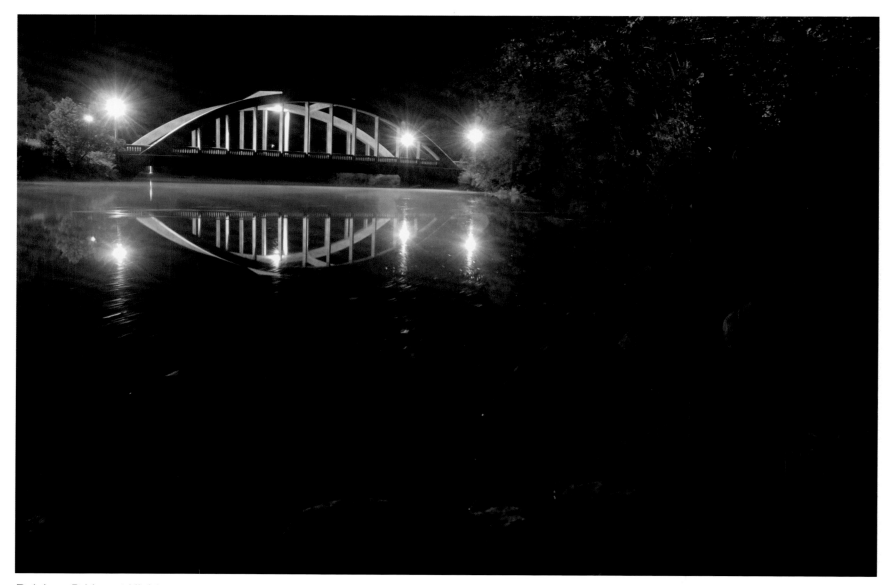

Rainbow Bridge at Night

Daron W. Krueger

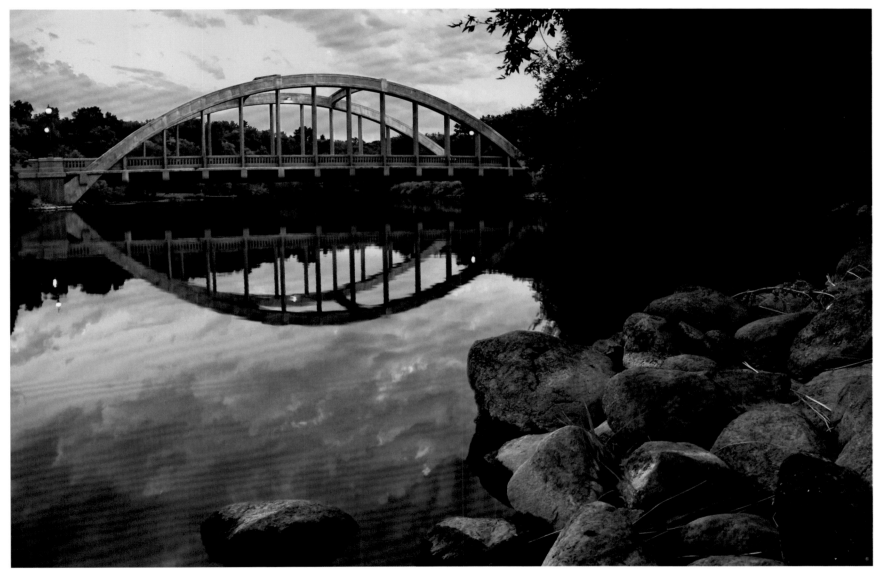

Rainbow Bridge

Clint Saunders

Peace Gardens

Clint Saunders

Fall Color at Little Yellowstone

Clint Saunders

The Badlands

According to Daron

The Badlands are a wonder to behold and a joy to explore. Their rugged beauty has inspired artists and photographers for generations.

I always enjoy looking for new ways to portray the intrinsic beauty of the area. With some hiking, one can always find new vistas for grand landscapes, as well as interesting rock formations and other geologic oddities for creating more intimate scenes.

I especially enjoyed our winter excursion into the region while shooting for this book. It was my first time seeing the Badlands under a layer of snow and it was simply gorgeous. The weather was perfect and the bluffs took on a majestic feel, standing bold and clean against a deep blue sky. It was magical.

While the Badlands have been extensively photographed and explored, there are always opportunities to make original photographs that showcase this geological wonder.

The Badlands

According to Clint

The badlands are probably the most recognized area of North Dakota, and, in my opinion, probably the hardest area to photograph. Their vast beauty and ruggedness take your breathe away and leave you standing in awe at the amazing scenery before you. Translating that beauty into a successful photograph is challenging.

I've seen hundreds of photos of the badlands, and many of them look the same. The area has been well photographed for years. The challenge for me was getting shots that were unique, shots that were different from the "normal" badlands photos you see on the market. The most popular shots come from overlooks which look out on the vast rugged terrain. I wanted to get a few photographs that give people a unique view of the badlands, some subjects and areas that people aren't expecting to see. On our fall trip we decided to hike and shoot from the valley floor near the river.

We chose to sleep in the van so that we could be up and in position before the sun came up. We started hiking in the dark, which was a little nerve racking for me knowing that there are wild bison everywhere, but we didn't run across any. We were rewarded for our efforts as a fog about ten feet high rolled in over the ground but gave way to a crisp, clear blue sky above. The early morning light, the fog and cold fall temperature helped to create a perfect atmosphere for some beautiful photos. As the morning progressed, the sun rose higher and the fog burned away revealing some truly magnificent colors and probably one of the best days shooting we've ever had.

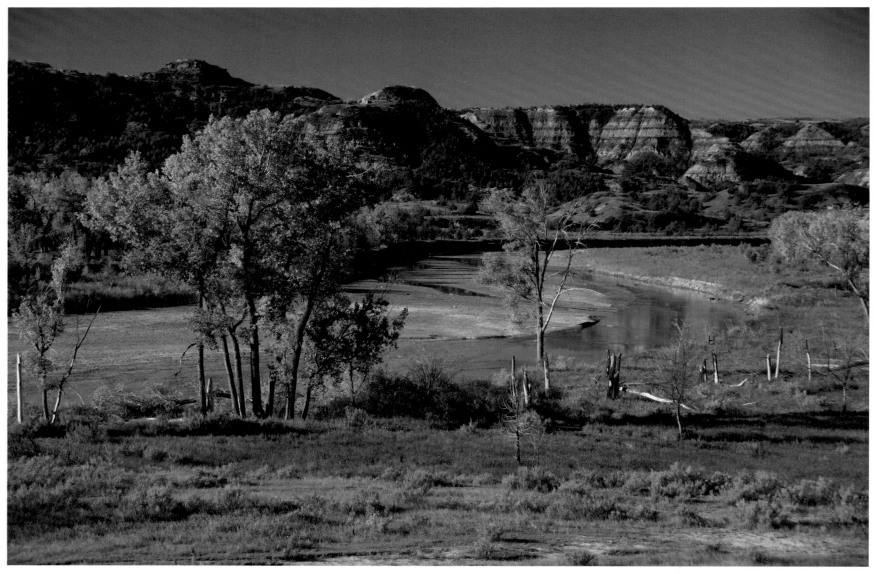

Badlands Serengeti

Daron W. Krueger

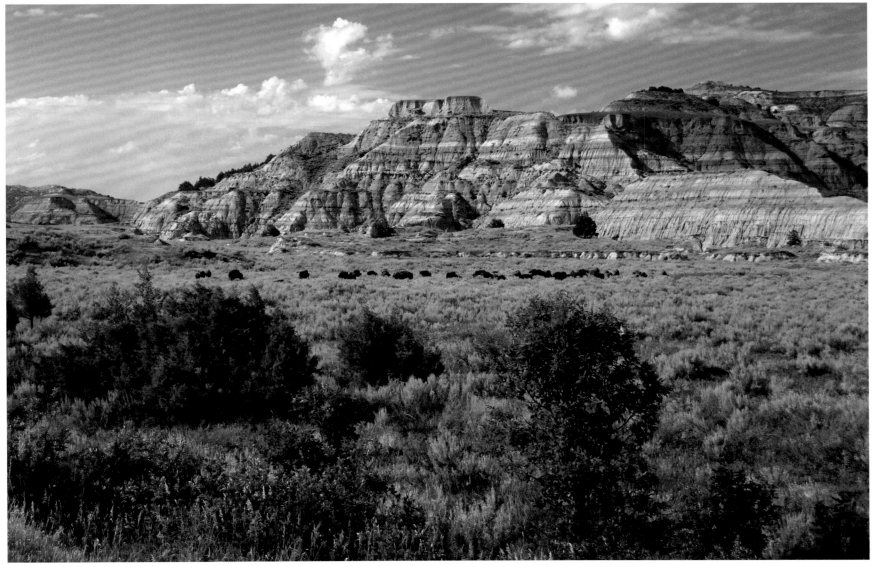

Badlands #7

Daron W. Krueger

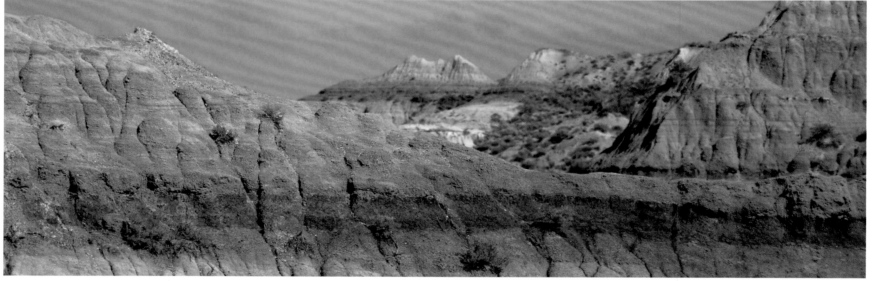

Badlands Panorama #4

Daron W. Krueger

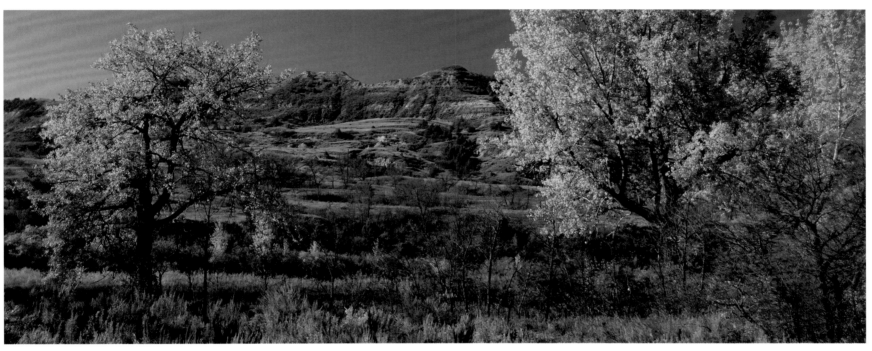

Badlands Autumn Panorama #4 Daron W. Krueger

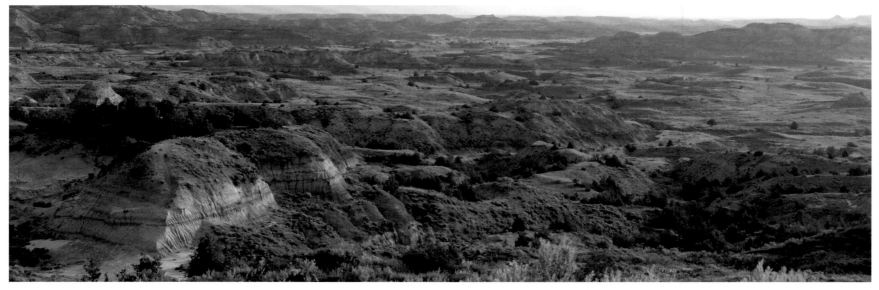

Badlands Panorama #3 Daron W. Krueger

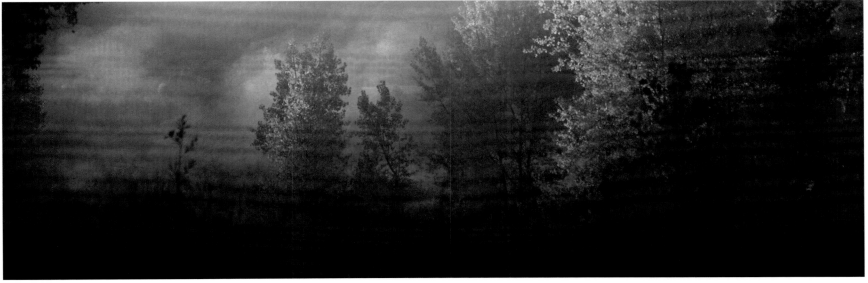

Fall Morning Badlands 04 Clint Saunders

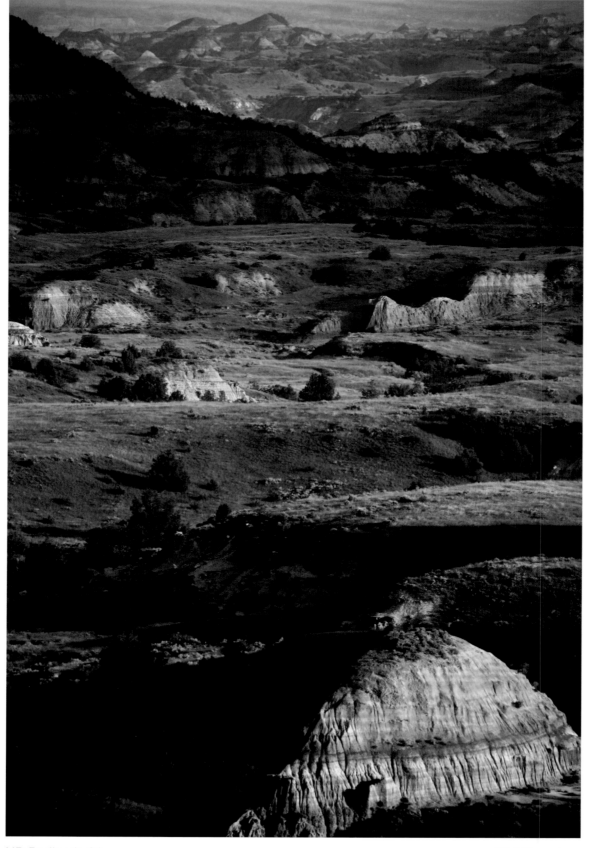

ND Badlands 01 Clint Saunders

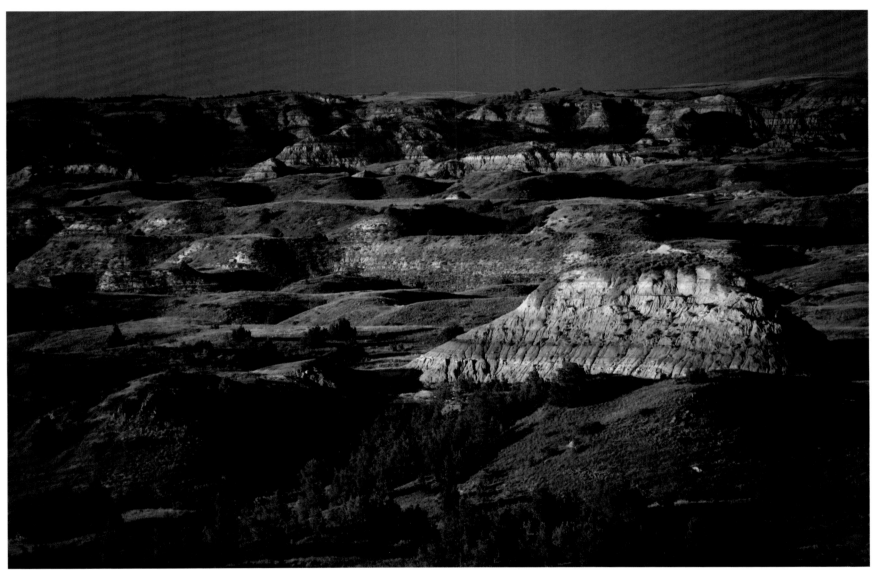

ND Badlands 06

Clint Saunders

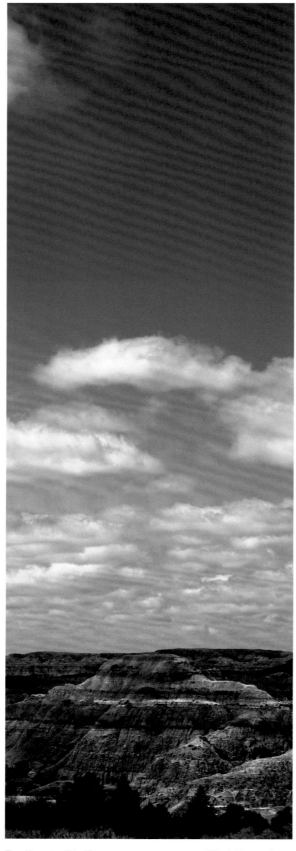

Badlands Bluff Clint Saunders

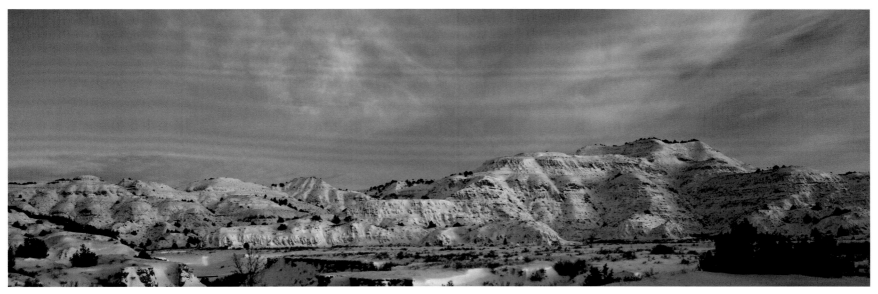

Winter Morning

Clint Saunders

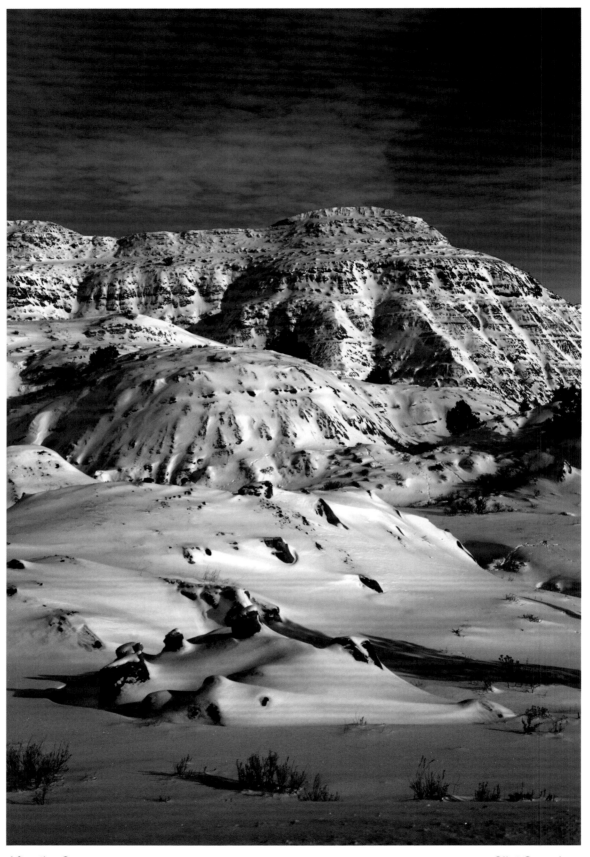

After the Snow

Clint Saunders

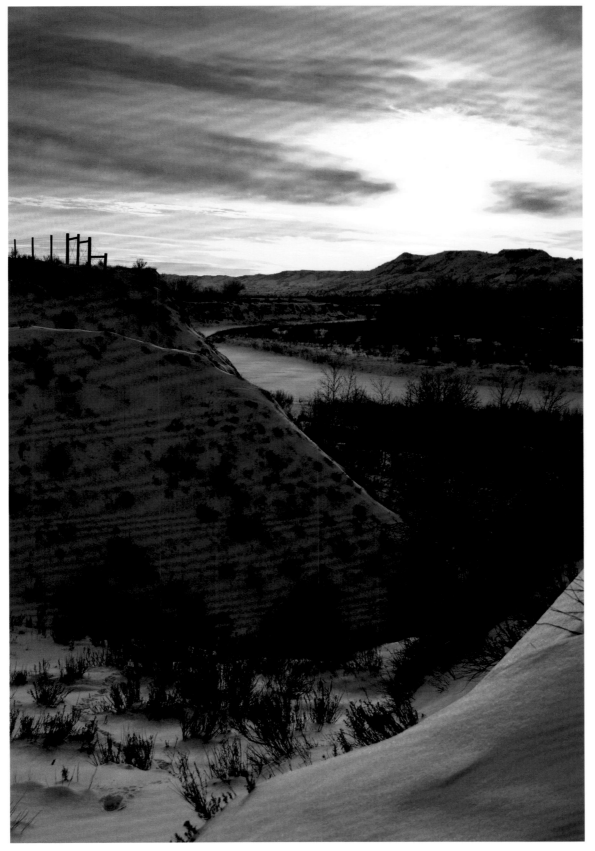

Badlands Winter #1

Daron W. Krueger

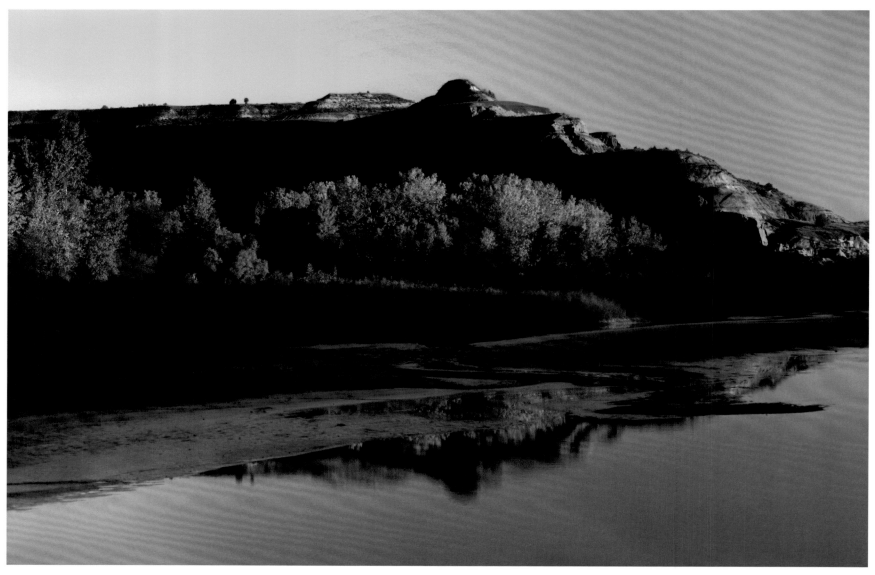

Fall Morning Badlands 01

Clint Saunders

Fall Morning Badlands 02

Clint Saunders

Wildlife

According to Daron

Since I have always enjoyed hunting, pursuing wildlife images was inevitable. From the exhilaration of pursuit to the anticipation of waiting quietly in the woods, the thrill of the hunt is even stronger with a camera in hand than with a weapon.

When photographing wildlife, I attempt to compose images that incorporate some environmental elements--photos that show the animal being a part of nature. Rather than recording a species for wildlife enthusiasts, I hope to create scenes that are a window to nature for everyone to enjoy.

An additional component to photographing wildlife is the role that a specific animal's personality can play in the success of an image. My photo of a Great Horned Owl illustrates the unpredictability of wildlife's demeanor. While most owls take flight the moment I exit my vehicle, this one sat perched in the window and glared at me as I approached in full view. With no cover to conceal my advance, I crept slowly, taking a shot, crawling forward a foot and taking another shot, until I got close enough for the photo I wanted. It was a surreal exercise that taught me never to assume it is impossible to reach the position I need for an effective wildlife image.

Wildlife continues to be one of my favorite subjects, for the challenge it presents and the opportunity to absorb the ambience of nature.

Wildlife

According to Clint

Photographing wildlife takes a great deal of patience and dedication, and that is why most of the images in this section are Daron's.

While I've known Daron to spend eight hours stalking a moose waiting for the perfect shot, I'm more likely to spend eight minutes waiting for that shot before I get bored and start shooting close-ups of the texture on a tree, or abstract forms in rushing water.

My idea of shooting wildlife is getting lucky enough to have them within walking distance of the road, and preferably close enough so that I can shoot from the car window. It's because of this that I don't have very many wildlife photos, because the reality is that if you want great wildlife photos, you have to hike a lot and have a ton of patience. If it wasn't for Daron's love of stalking wildlife, we'd never have enough photos to do a wildlife section.

As a side note, while we do not normally digitally alter our photographs, I decided to play with my "Winter Bison" shot in order to do something more creative and fun with it. I really liked the end results and have decided to hang the altered print in the gallery as well as put it in the book.

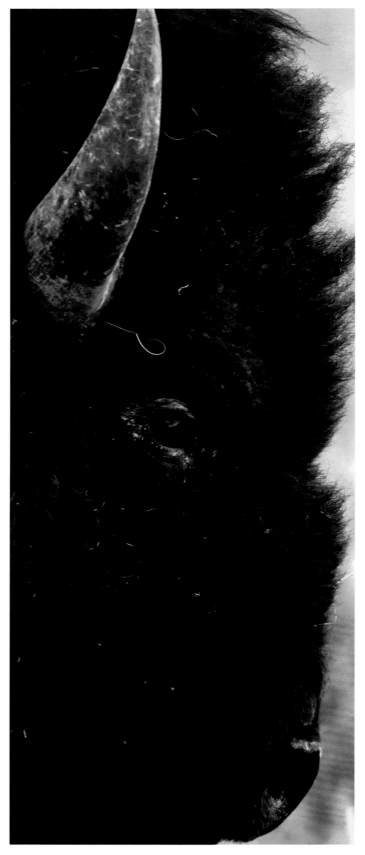

Bison Profile Clint Saunders

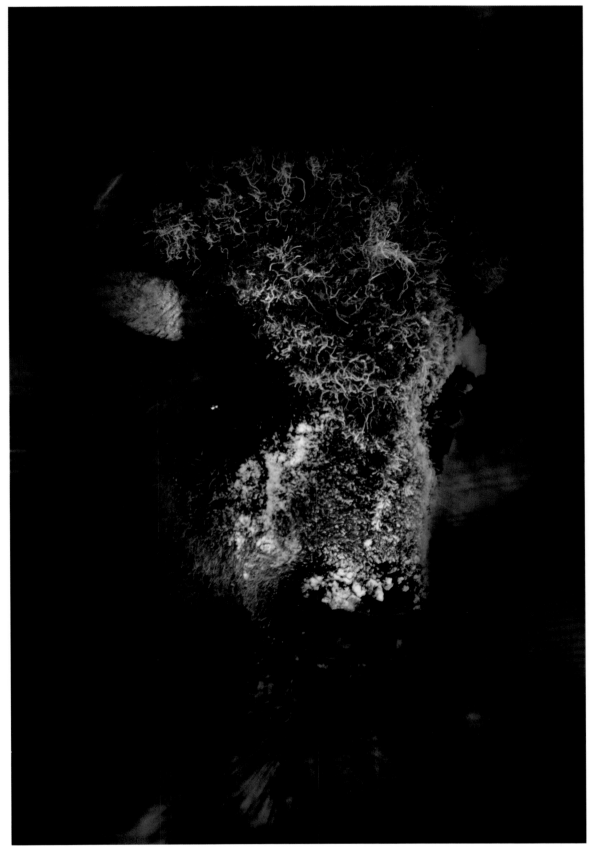

Winter Bison - (digitally altered) Clint Saunders

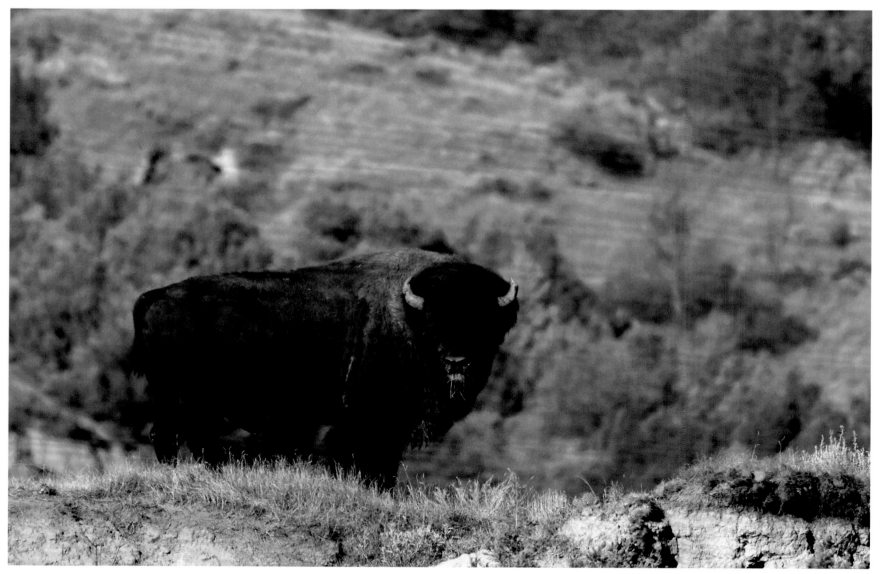

Badlands Bison #5

Daron W. Krueger

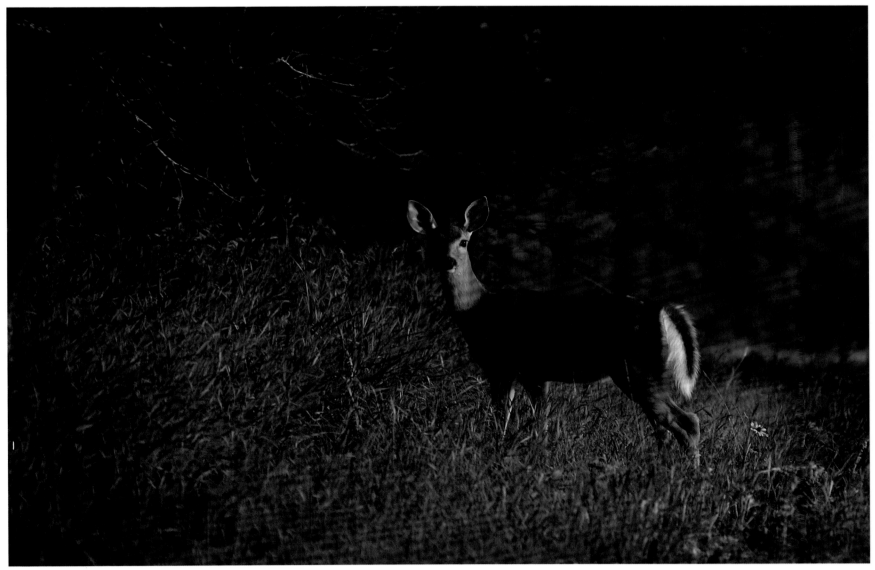

Pembina Whitetail

Clint Saunders

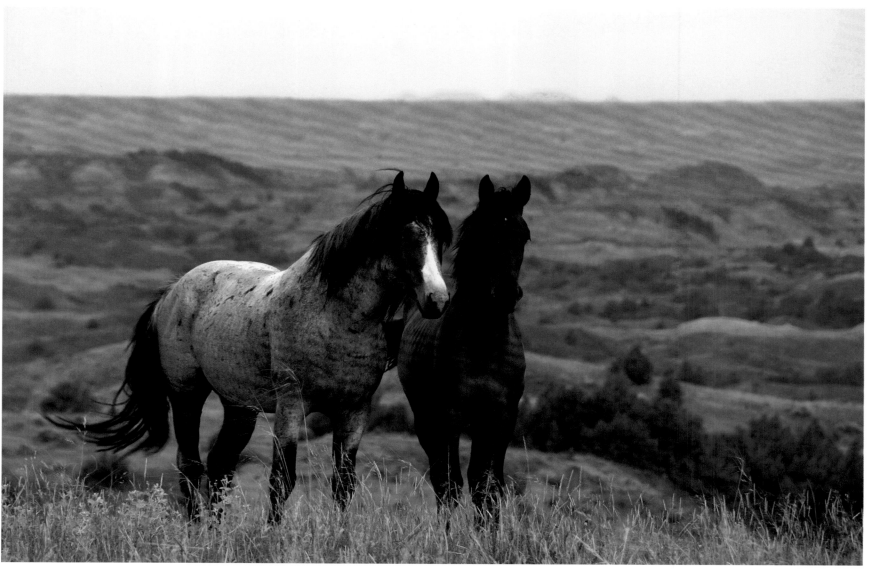

Badlands Horses

Daron W. Krueger

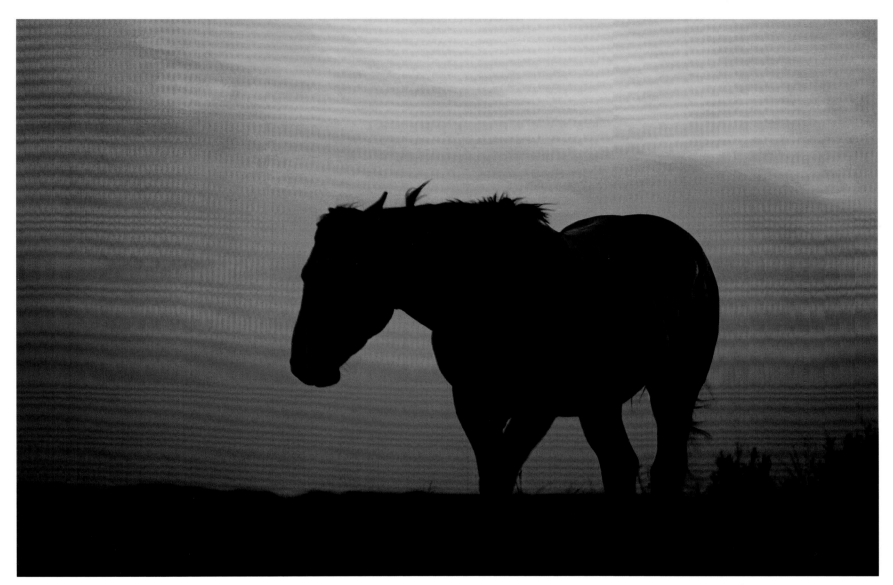

Wild Horse Sundown Clint Saunders

Wild Horses 11 Clint Saunders

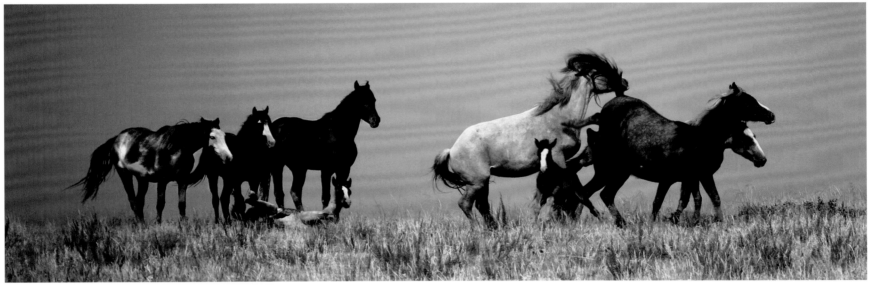

Wild Horses 18

Clint Saunders

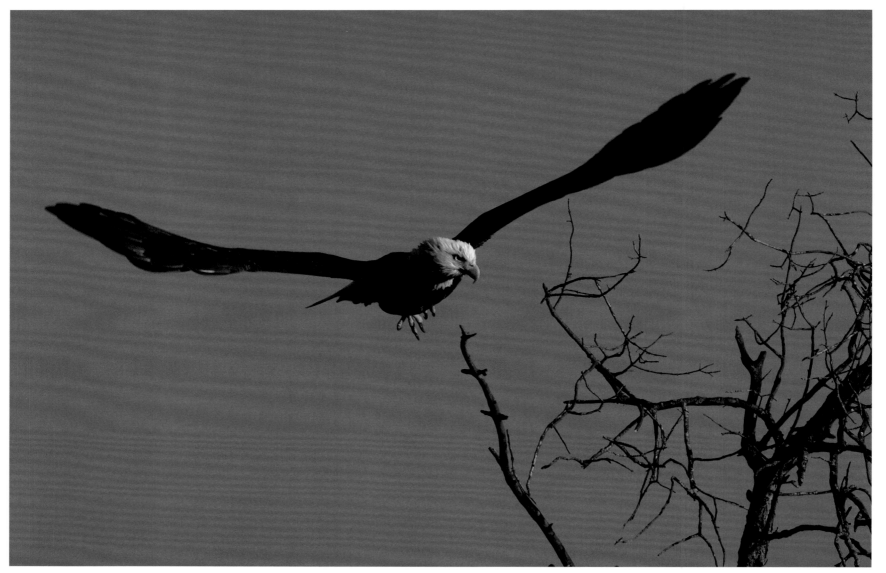

Eagle Flight Daron W. Krueger

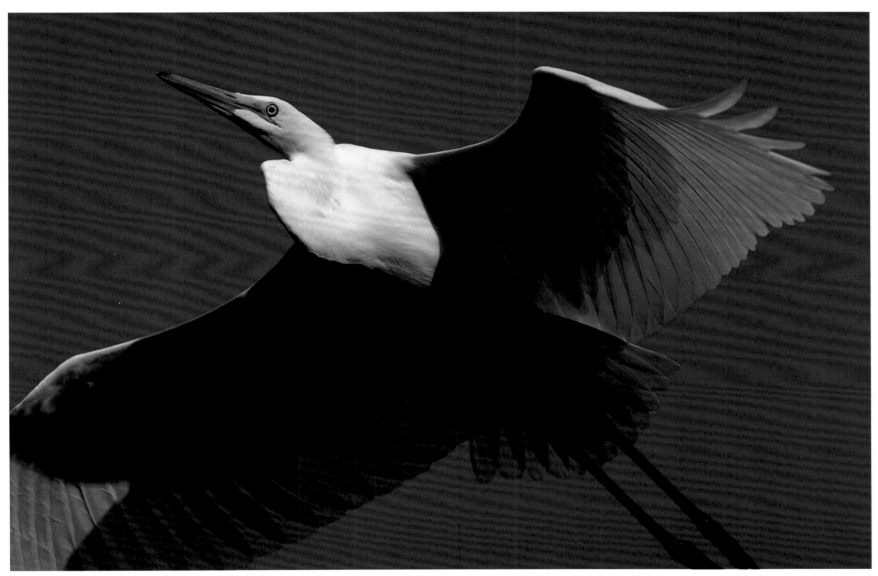

Great Egret #2

Daron W. Krueger

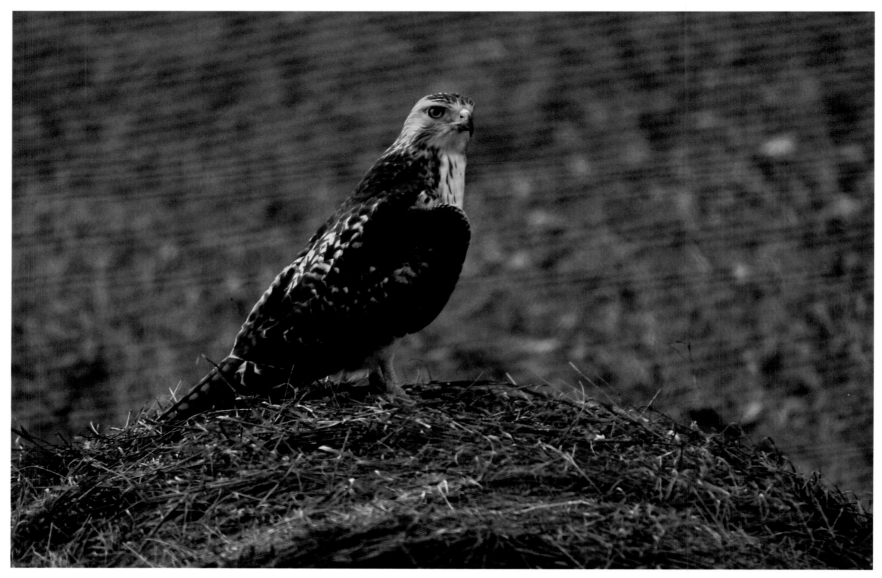

Hawk

Clint Saunders

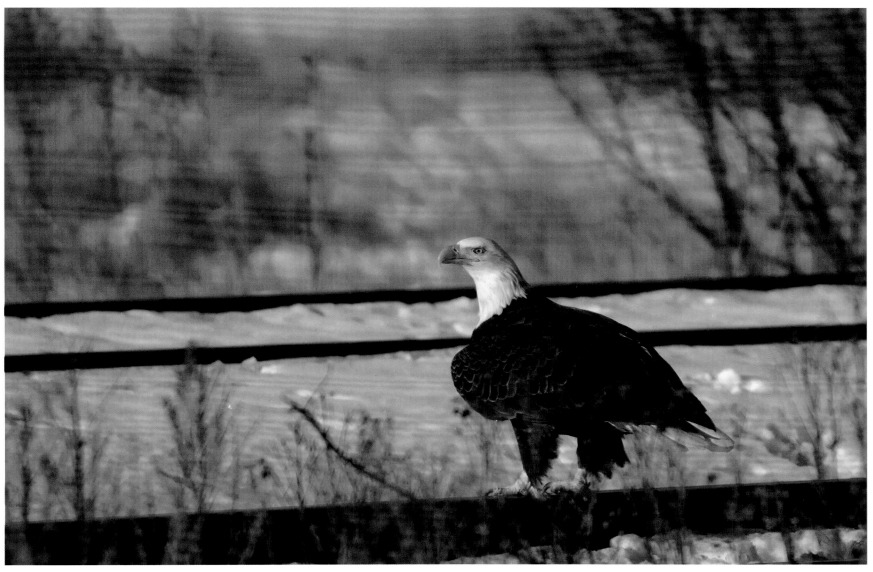

Eagle Tracks

Daron W. Krueger

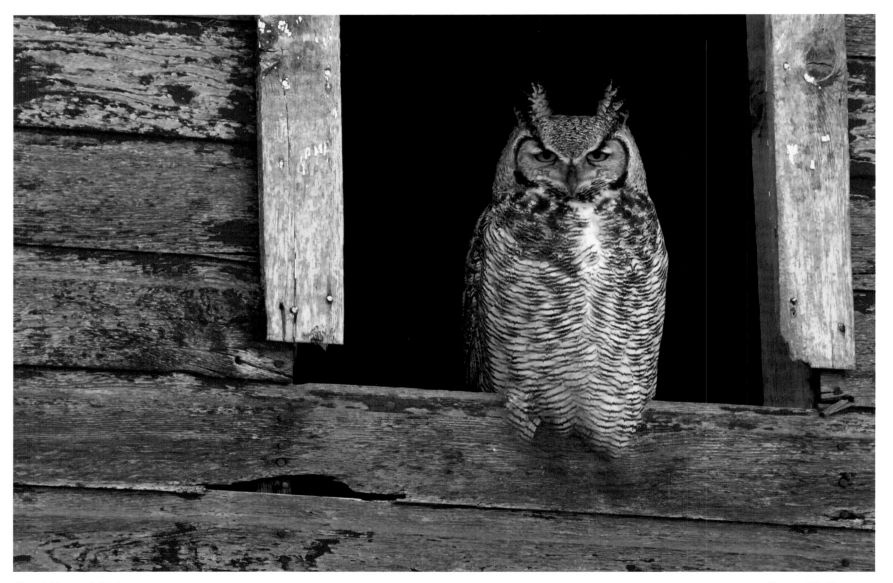

Great Horned Owl

Daron W. Krueger

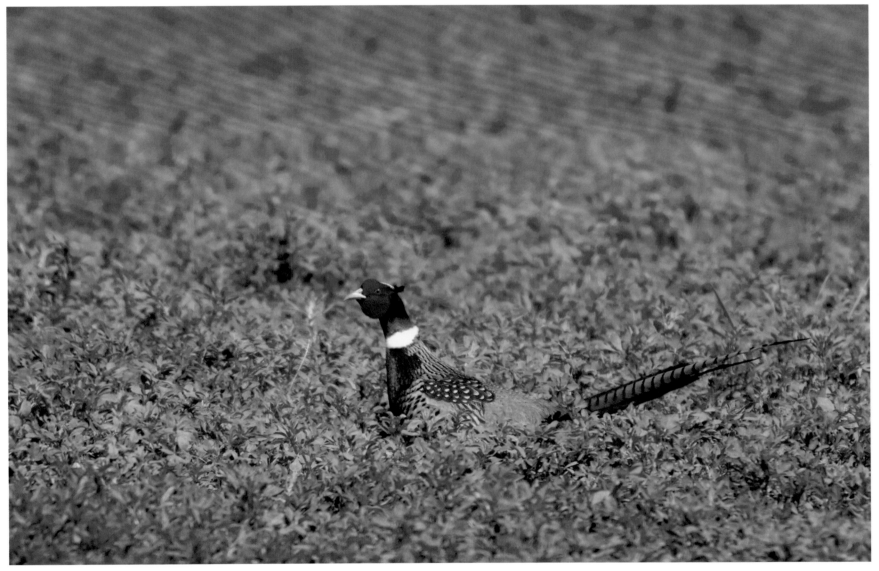

Pheasant

Daron W. Krueger

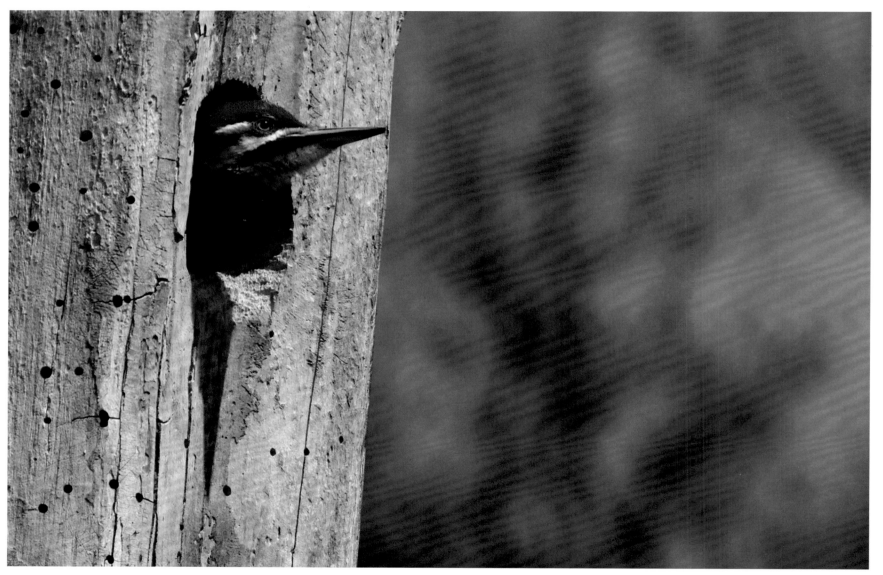

Pileated Peeking

Daron W. Krueger

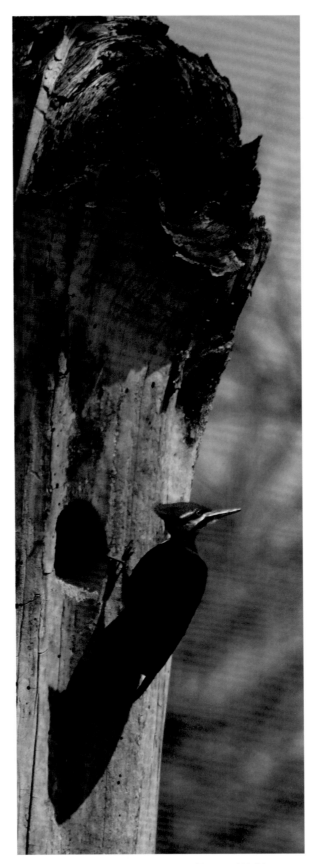

Pileated Woodpecker Daron W. Krueger

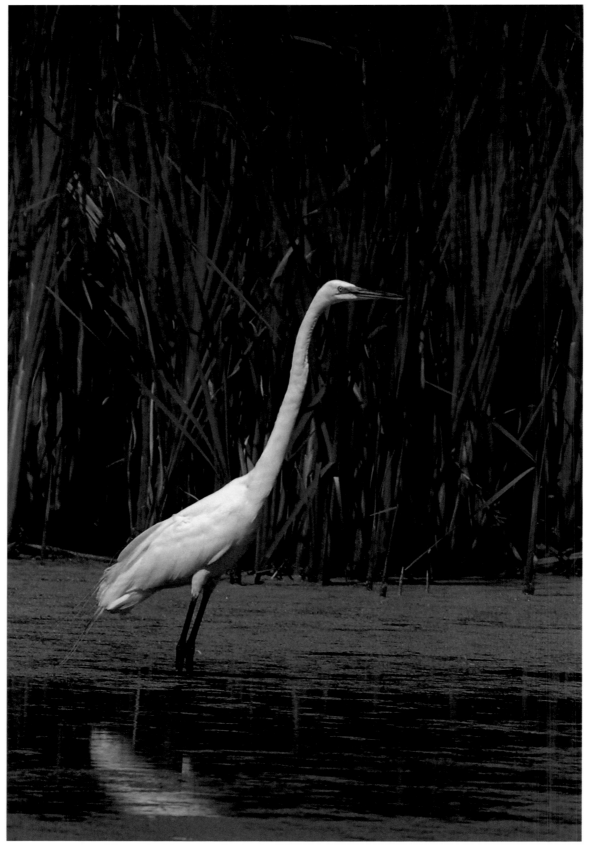

Great Egret Daron W. Krueger

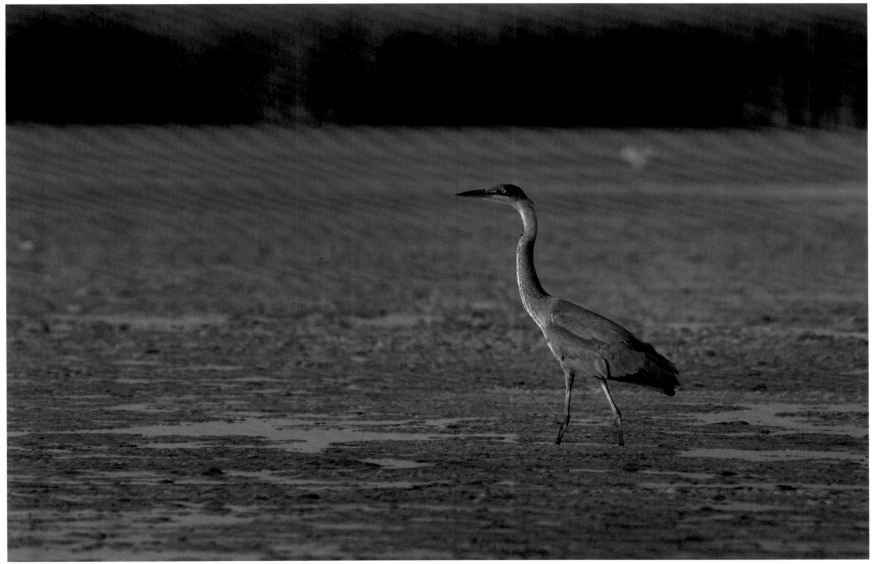

Great Blue Heron

Daron W. Krueger

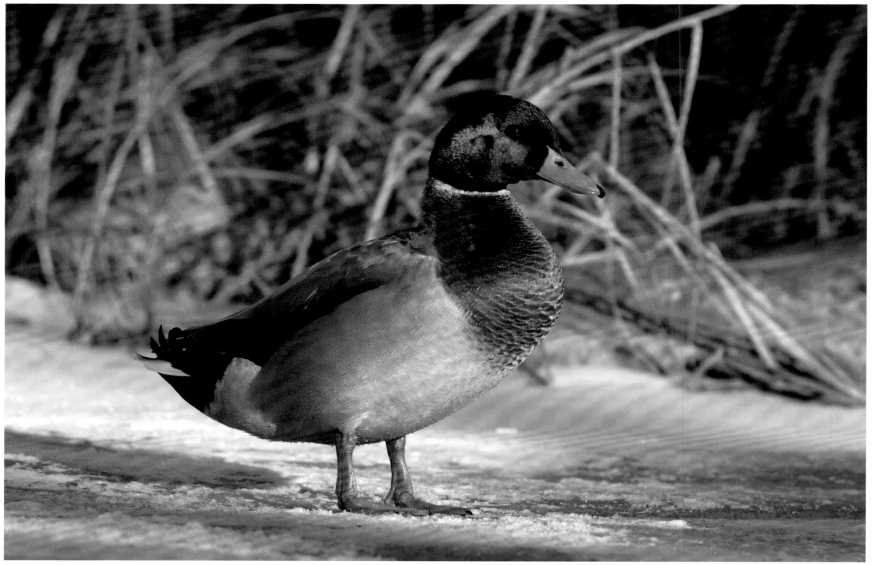

Winter Mallard

Daron W. Krueger

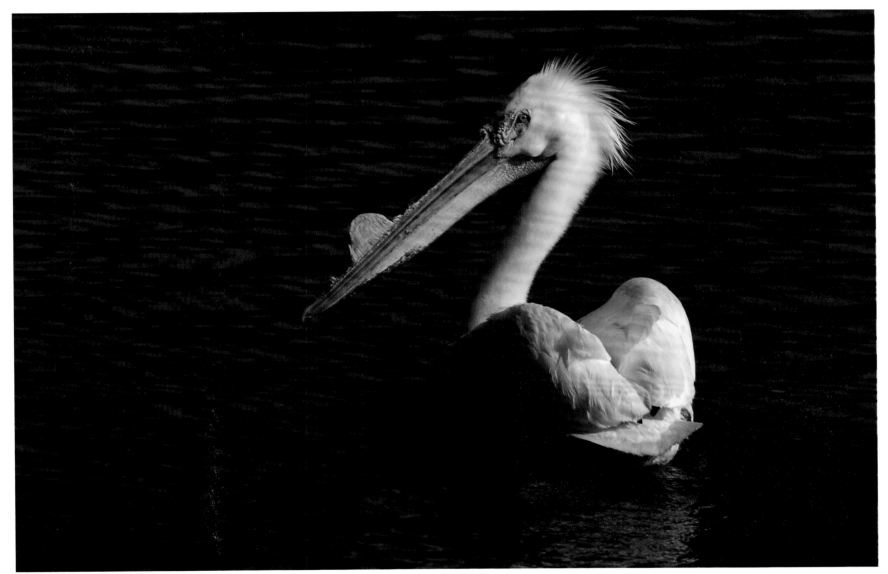

White Pelican #3

Daron W. Krueger

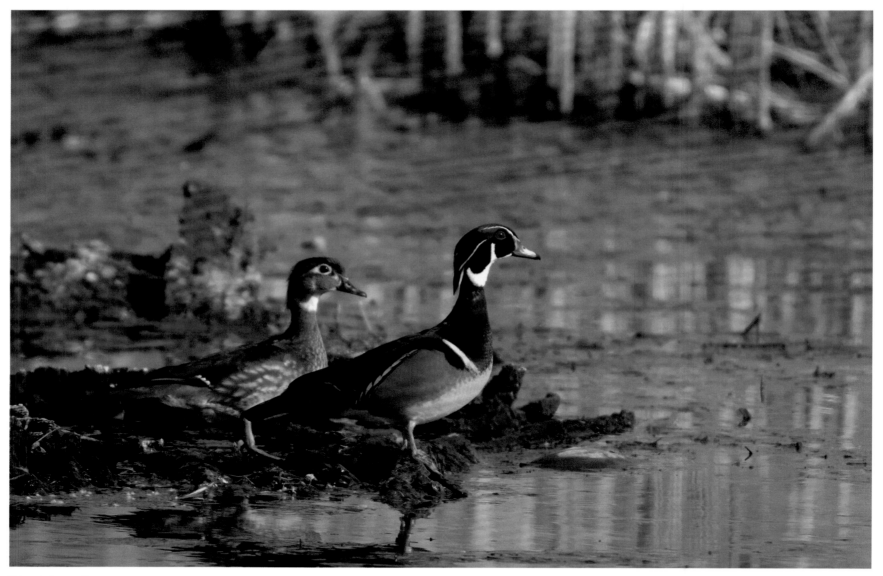

Wood Duck #7

Daron W. Krueger

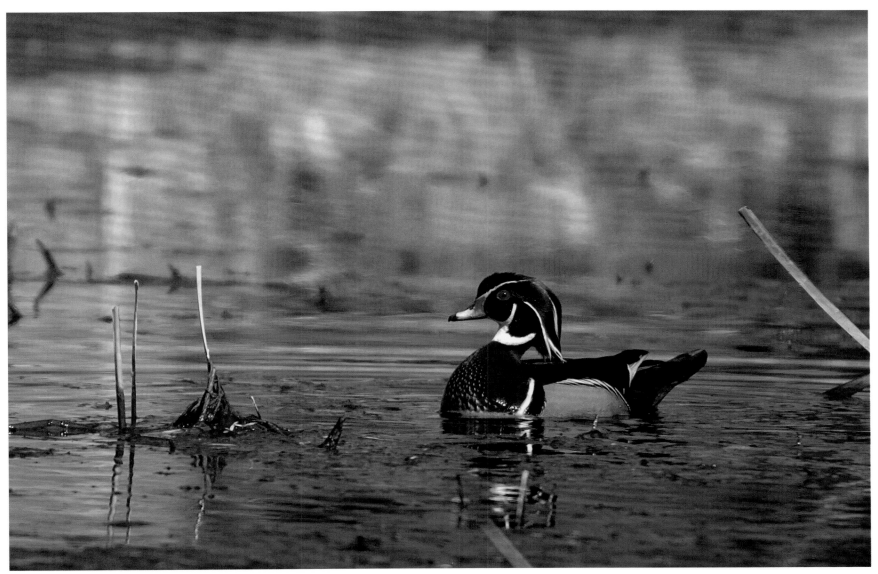

Wood Duck

Daron W. Krueger

Lakes, Rivers, and Streams

According to Clint

As a photographer, one of my favorites subjects in landscape photography is water. Water works as a foreground, middle ground, background, or subject. Whether it's rushing, rippling, or smooth and reflective, water always seems to work well in photos.

I also like listening to the water because it is very soothing. Be it rushing water over rocks in a river, the pounding of a waterfall, the trickling of a spring, or the soft lapping on the shoreline of a lake, even smooth and reflective water has a sound of calm and still. Equally soothing are the colors the water picks up from light, skies, and reflections. Every time I see a magnificent sky, the first thing I look for is a body of water to photograph with it.

One of my favorite moments creating this book was standing on the shore of Lake Metigoshe in the fall and photographing the sunrise as the fog slowly lifted. There is something very peaceful and romantic about standing on the shore of a lake at sunrise and sunset.

Lakes, Rivers, and Streams

According to Daron

I truly enjoy using water in scenic photography. The aura that water adds to a scene translates well in photographs. The flow of a river, cascading splashes in a stream, and rippling waves on a lake impart motion and invoke a sense of being there. The reflections on the water and the winding path of a river or stream provide depth. Reflections can also introduce elements from outside the frame of the photo, to add a new dimension to the image.

I especially appreciate how the feel of an image can be changed dramatically by using different camera angles. From a higher position, the sky reflecting on the water adds contrasting colors and an expansive feel to a photo, while shooting from a lower position fills the reflection with the colors of the shore and creates a more intimate, monochromatic scene. Both images can be breathtaking while conveying entirely different moods.

Exploring rivers, lakes, streams and the woods that surround them has always been one of my greatest delights, and the quest for an image that articulates the respite they offer multiplies the enjoyment these areas bring.

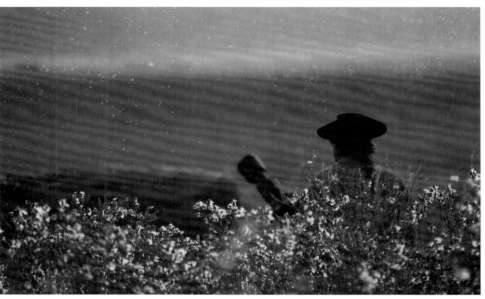

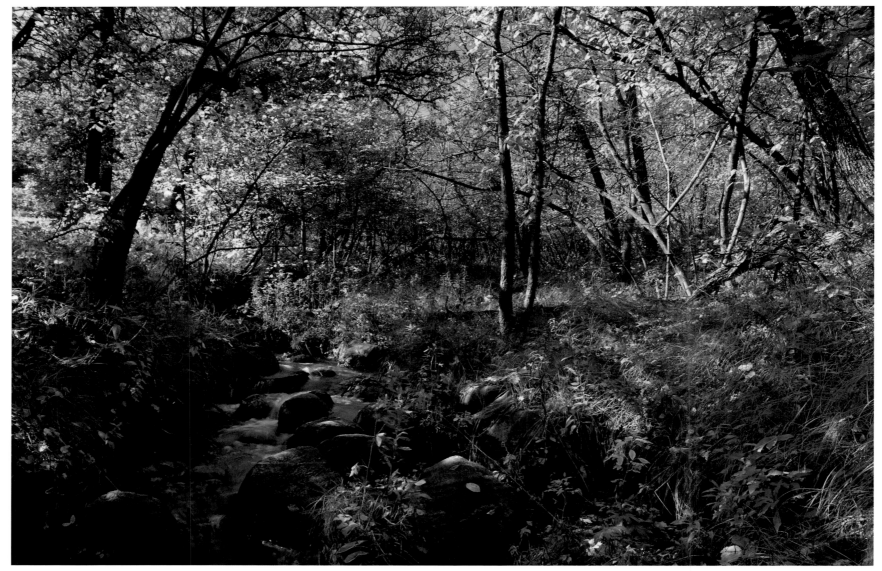

Autumn Tranquility

Daron W. Krueger

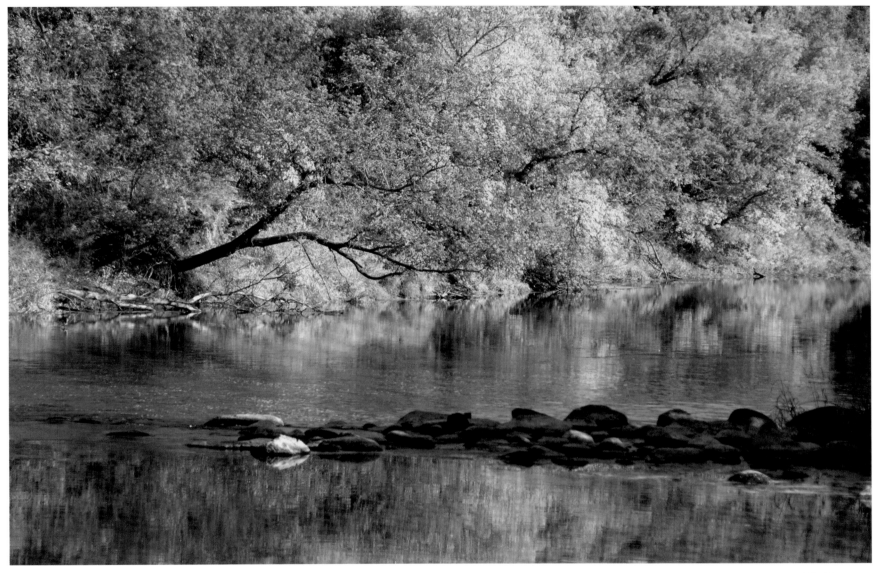

Peace Like a River

Daron W. Krueger

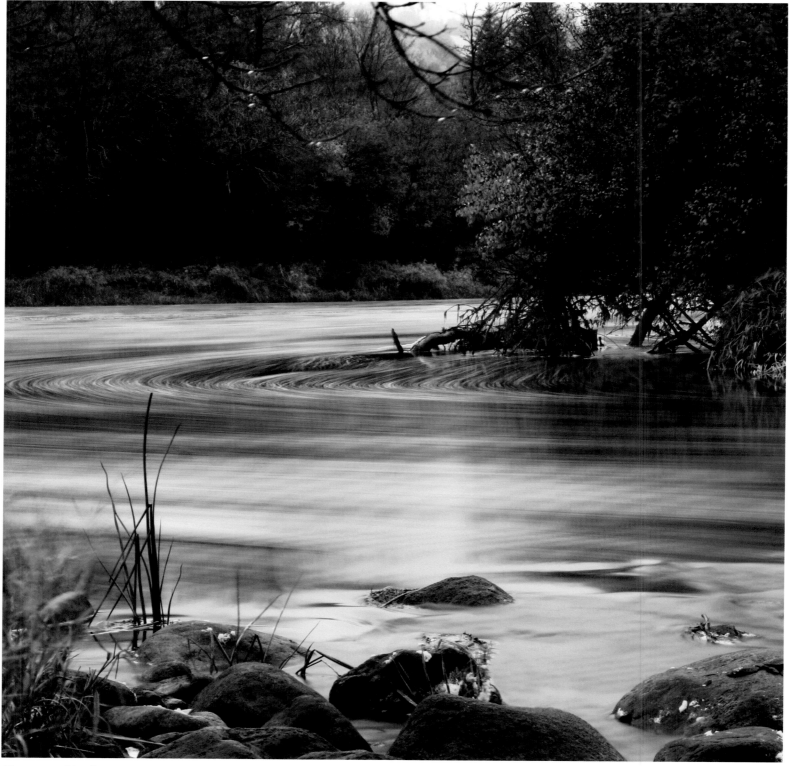

Sheyenne Tracks

Clint Saunders

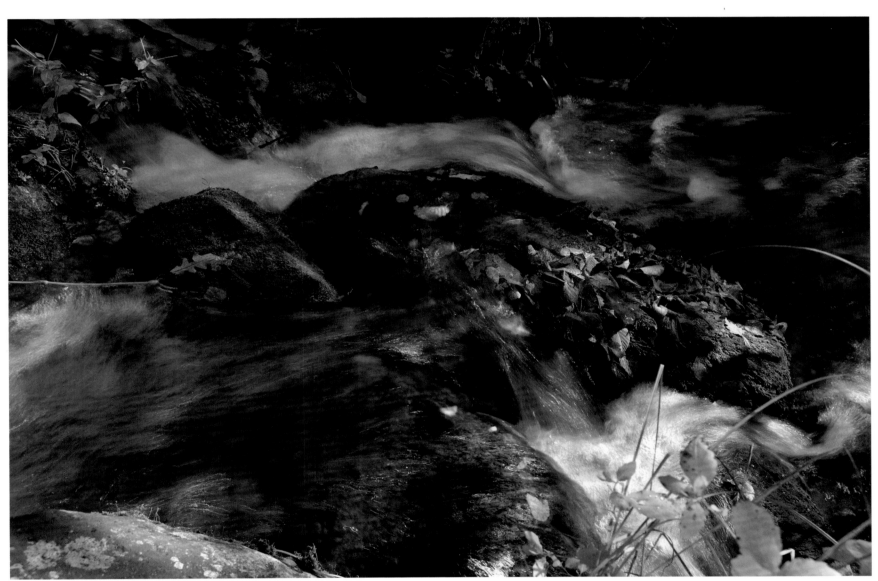

Cascade #2

Daron W. Krueger

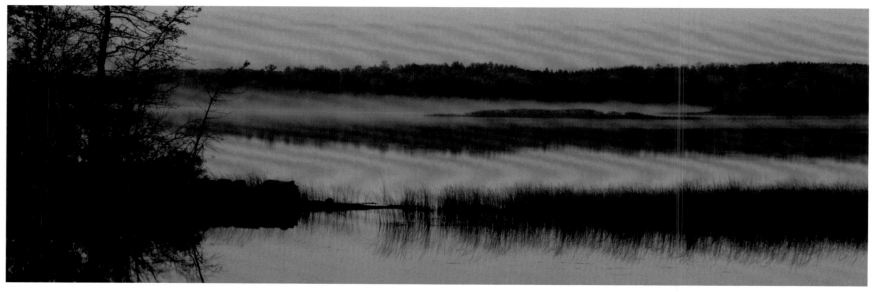

Peach Serenity

Daron W. Krueger

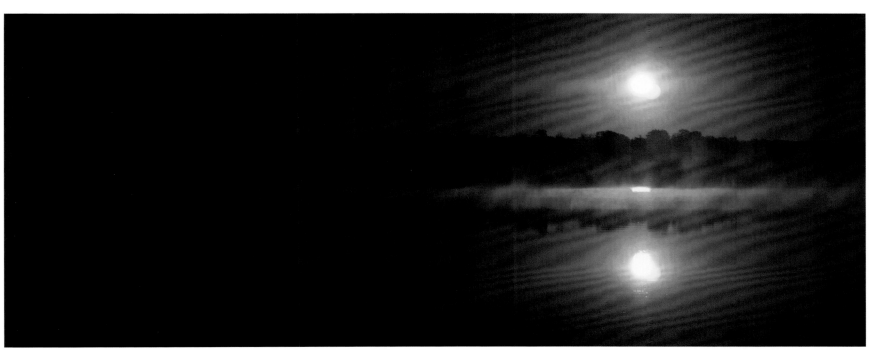

Metigoshe Sunrise 03 Clint Saunders

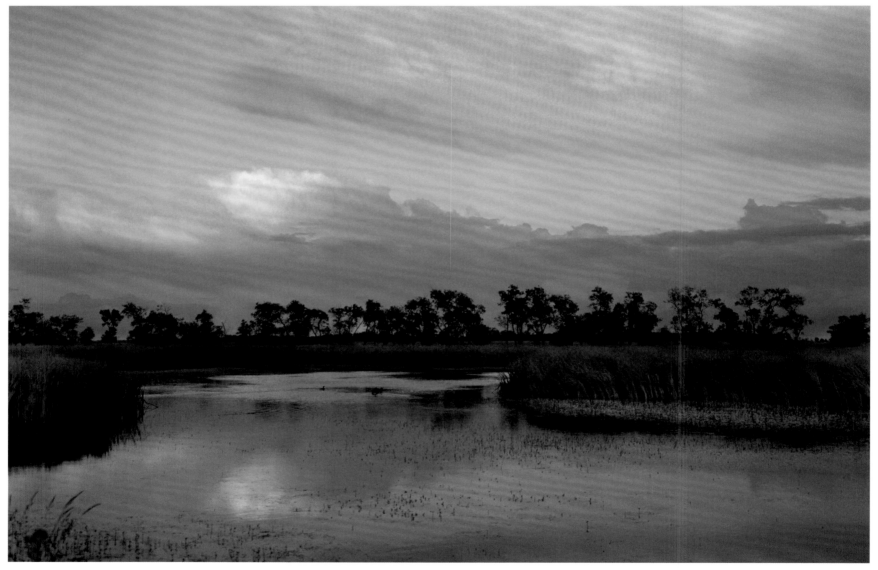

Passing Storm

Clint Saunders

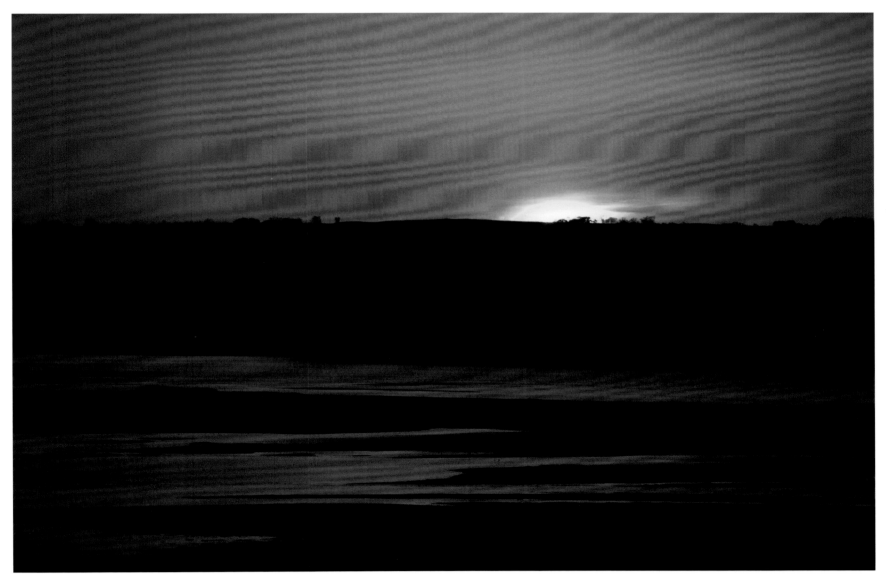

Missouri River Sunset

Clint Saunders

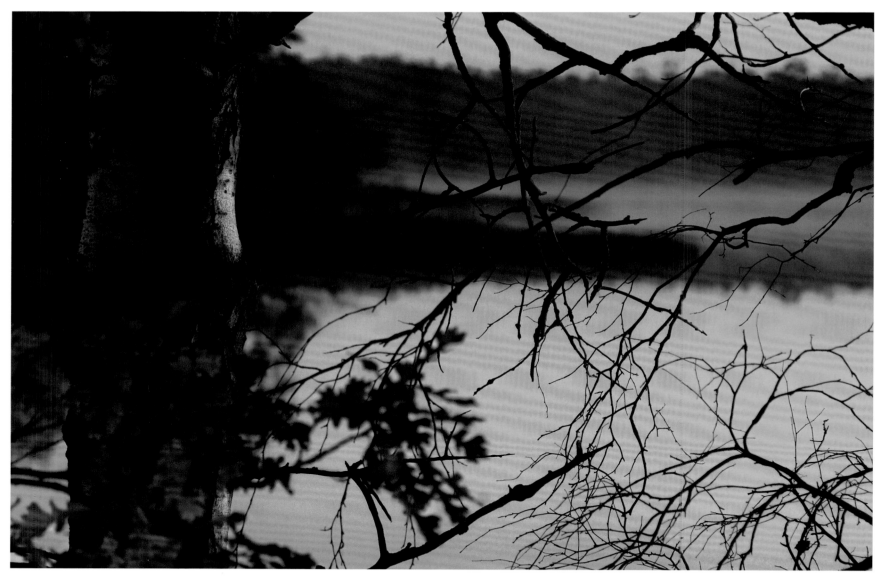

Morning Poplar

Daron W. Krueger

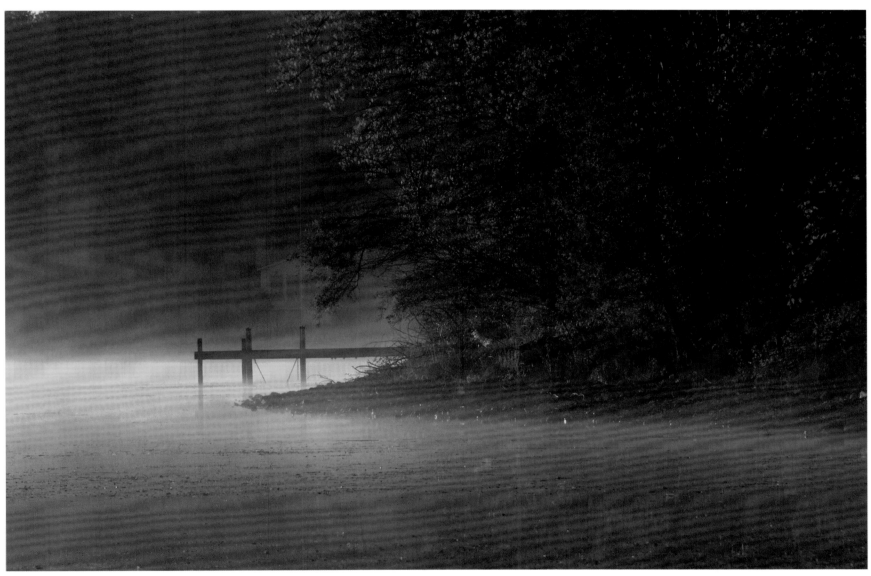

Autumn Mist
Daron W. Krueger

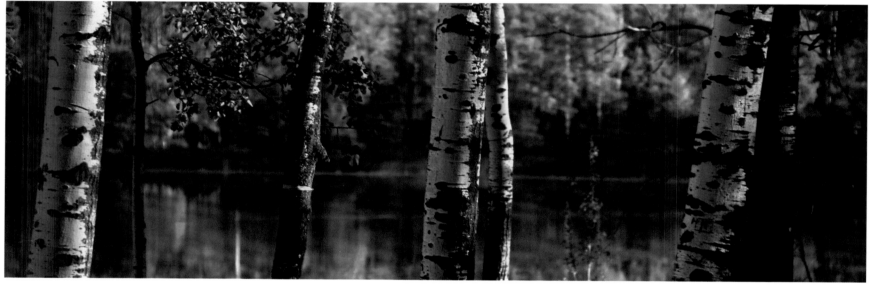

Fall Poplars Pano

Clint Saunders

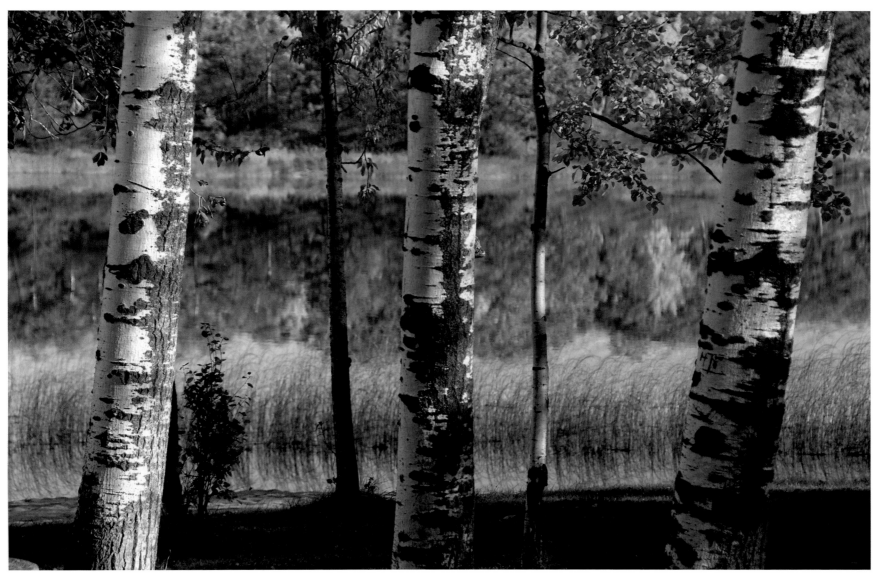

Three Poplars

Daron W. Krueger

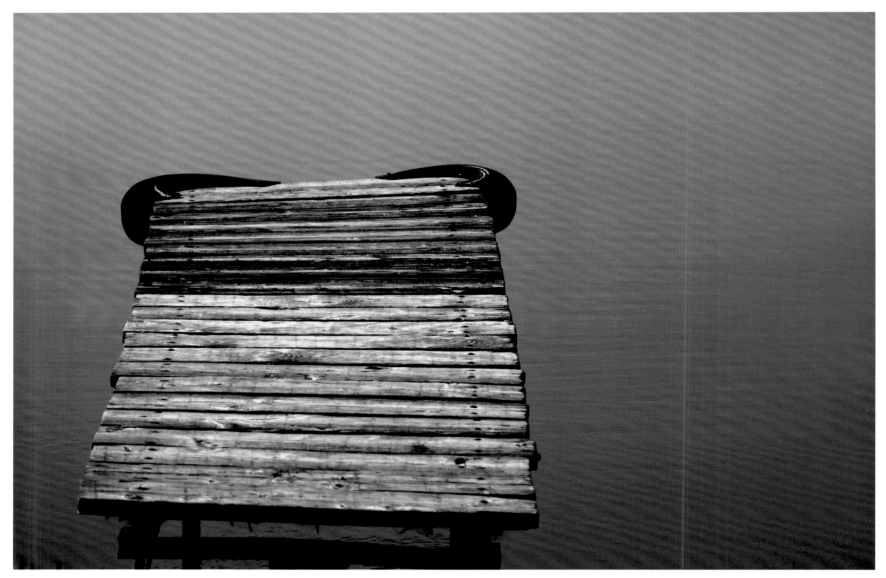

Pelican Lake Dock

Clint Saunders

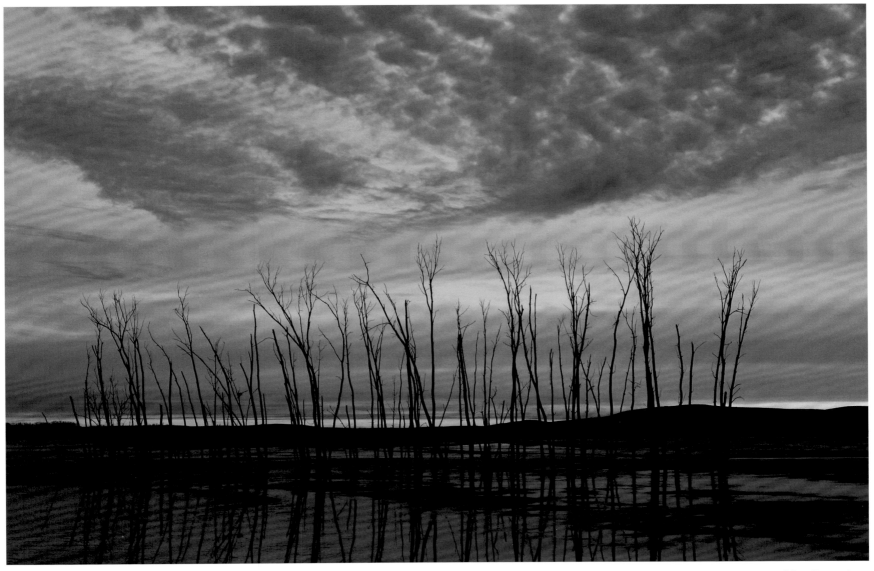

Trees ND

Clint Saunders

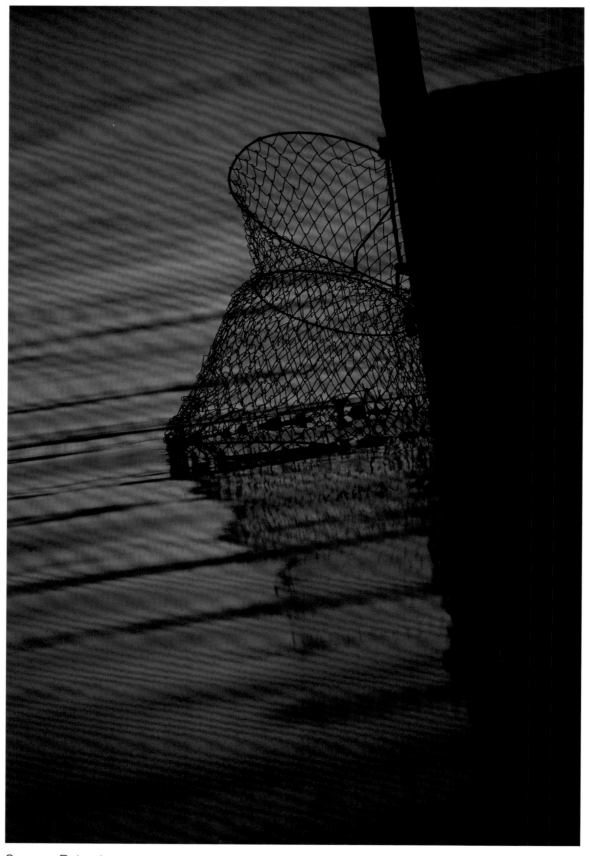

Summer Retreat

Clint Saunders

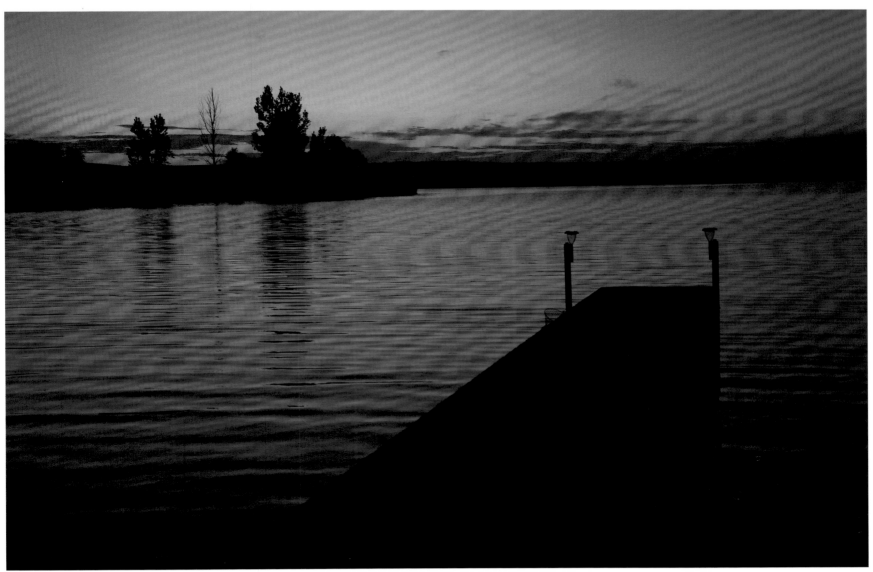

Lake Lamoure

Clint Saunders

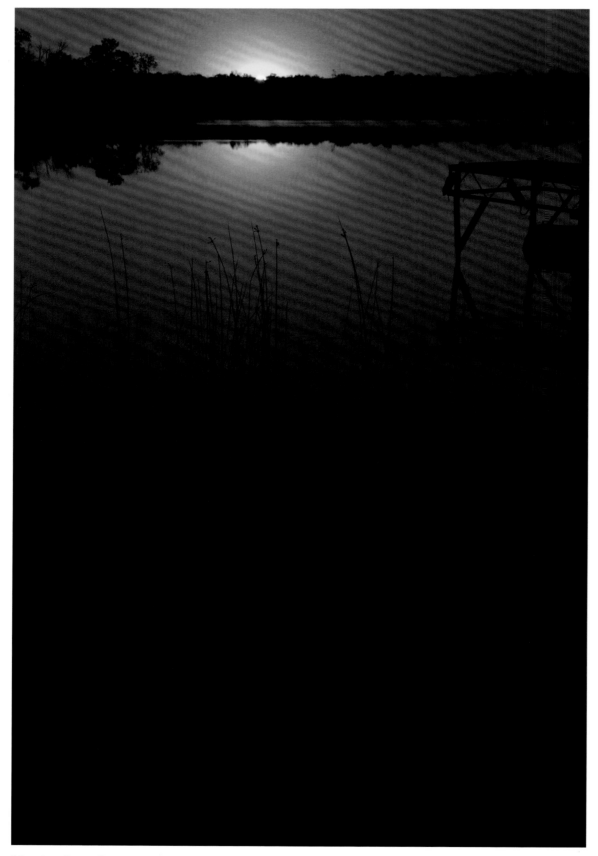

Morning Serenity

Clint Saunders

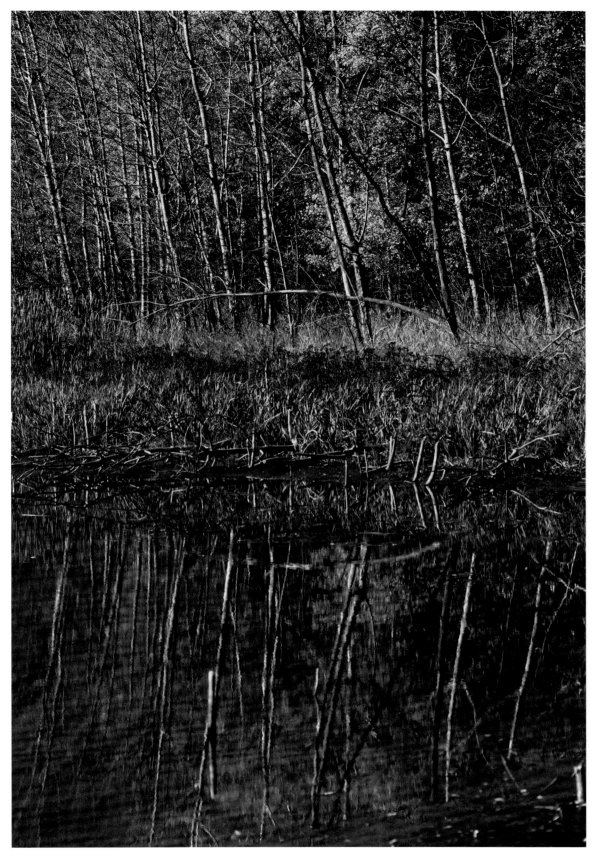

Pelican Lake Fall Reflection

Clint Saunders

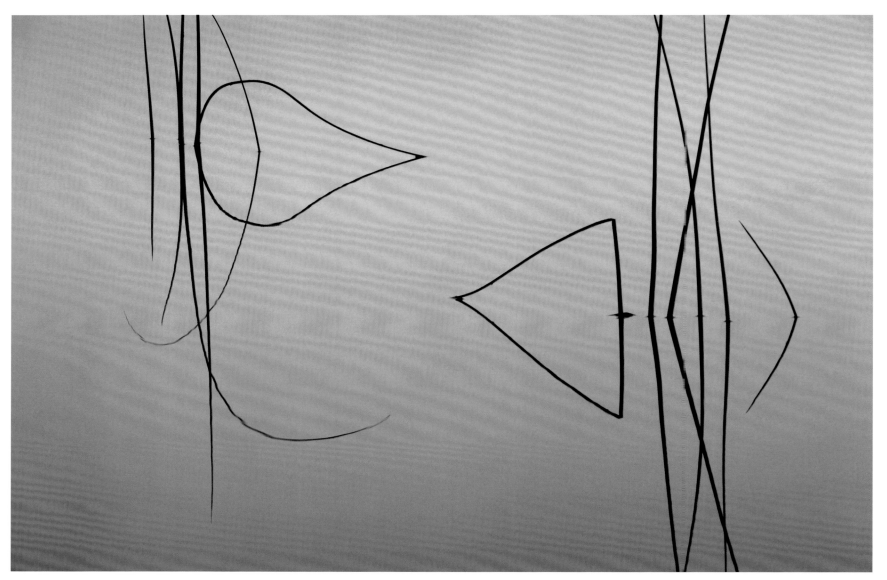

Reeds 01

Clint Saunders

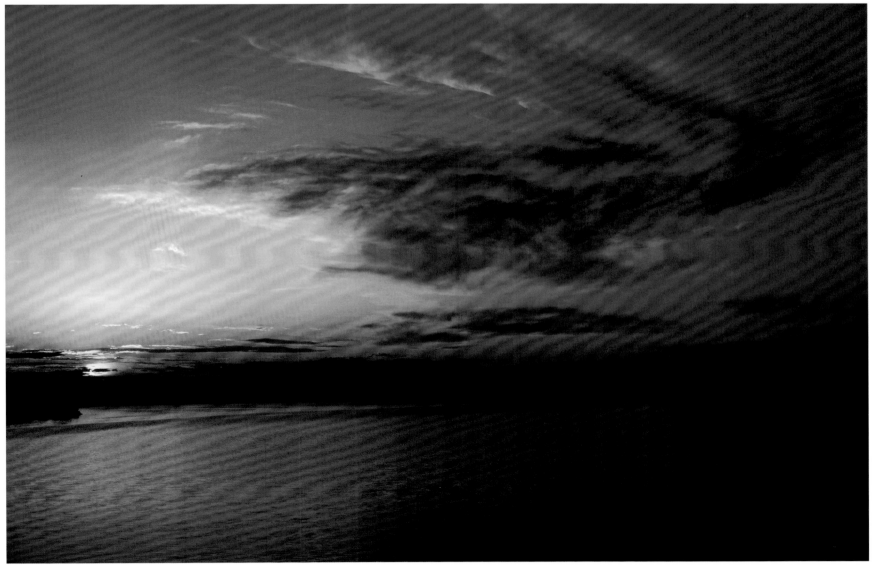

Scorpion Sunset Clint Saunders

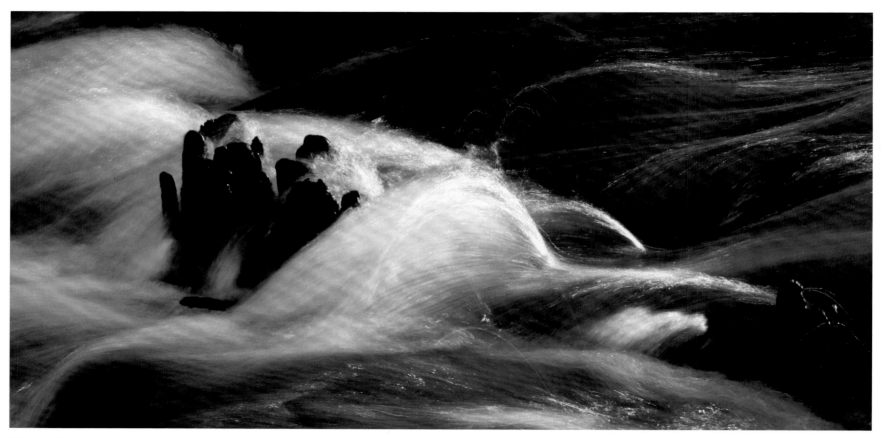

Water 02

Clint Saunders

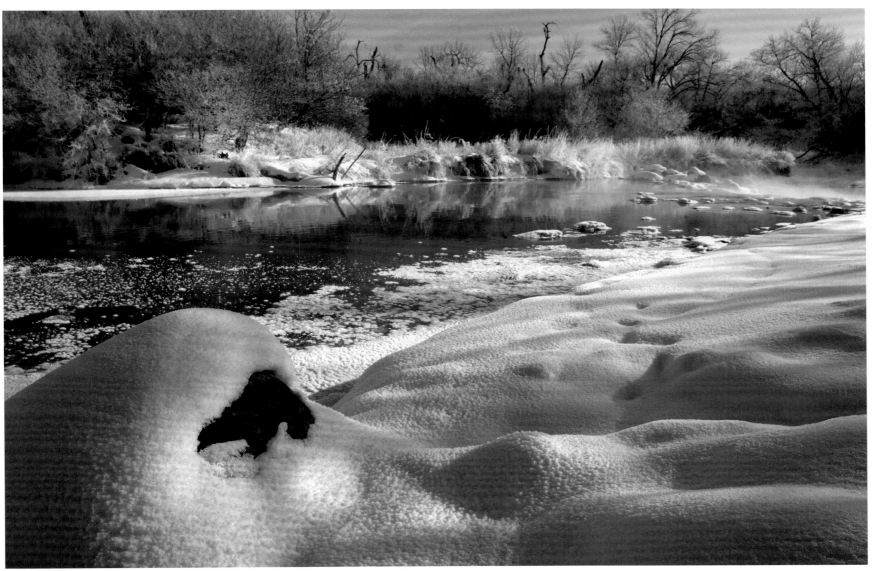

Sheyenne Valley Winter

Daron W. Krueger

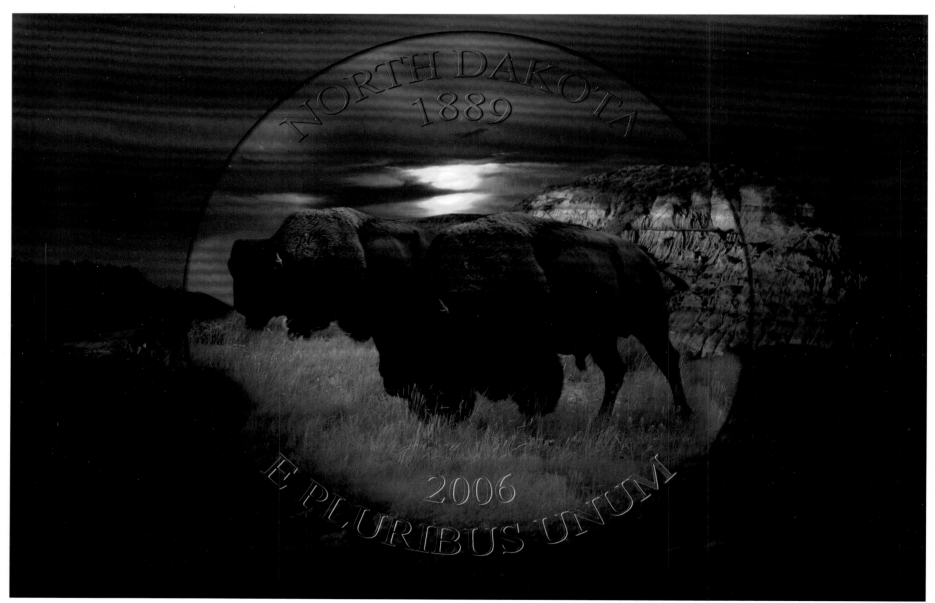

North Dakota Quarter

Clint Saunders & Daron W. Krueger

The North Dakota Quarter, (original design by the US Mint) consists of seven different Badlands photos montaged together to re-create the back of the North Dakota Quarter. This is a one-of-a-kind piece and there will only be 100 signed, limited edition prints made. Along with the limited edition prints, open edition posters are also available.

Prints of the North Dakota Quarter piece, along with any of the images in this book, and many more, may be purchased by contacting us through our web site.

www.opgart.com